IMAGES
of America

SNYDER COUNTY

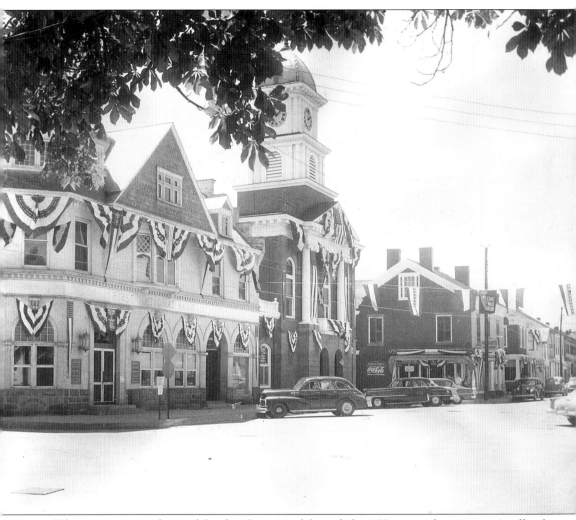

Fifty years ago, residents of Snyder County celebrated the 100 years of our county's official organization. Today we celebrate our sesquicentennial—150 years of progress. You are looking at the main intersection of Middleburg (Market and Main Streets), Snyder County's seat. Festively decorated with banners and traditional bunting are the First National Bank, the Snyder County Court House, and Aura Snook's drug store. Later, gala events recalling the county's rich heritage filled the streets.

IMAGES
of America

SNYDER COUNTY

Jim Campbell

ARCADIA

First published 2004
Reprinted 2004

Published by Arcadia Publishing,
Charleston SC, Chicago IL, Portsmouth NH, San Francisco CA

Printed in Great Britain

Library of Congress Catalog Card Number: 2003113872

For all general information, contact Arcadia Publishing:
Telephone 843-853-2070
Fax 843-853-0044
E-mail sales@arcadiapublishing.com
For customer service and orders:
Toll-free 1-888-313-2665

Visit us on the Internet at www.arcadiapublishing.com

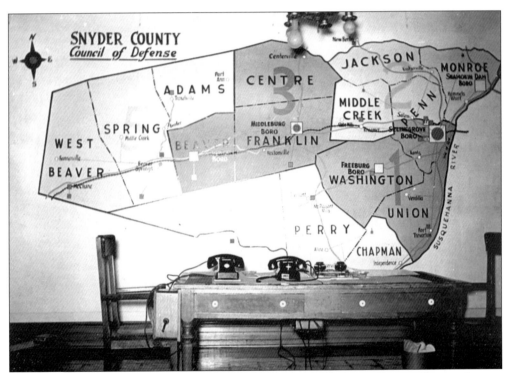

The above photograph, taken in July 1942, shows a map of the county's townships and many communities. The map took up most of one wall of the Snyder County Council of Defense (CD) headquarters, which was located at 10 North Market Street in Selinsgrove, in what is commonly known as the Pawling Mansion (now the law offices of Robinson & Robinson). The large and detailed map enabled CD workers to coordinate their activities during the uncertainty of the World War II era.

CONTENTS

Acknowledgments 6

Introduction 7

1. Down on the Farm 9

2. Business, Industry, and Commerce 15

3. Our Town 35

4. We, the People 49

5. The Three R's and Beyond 67

6. Sports, Games, and Recreation 81

7. Happenings 105

8. A County of Joiners 111

9. We Observe and Celebrate 121

ACKNOWLEDGMENTS

Snyder County represents the work of many. Two very important folks are William M. "Billy" Schnure, whose work *A Chronology of Selinsgrove, Pennsylvania*, is credited in *The Story of Snyder County* by Dr. George F. Dunkelberger, the other vital source. The Snyder County Historical Society was instrumental in seeing this project through. Others who gave generously of their time, knowledge, and cherished photographs include: Carolyn Arndt, Dave and Sarah Beaver, Pat Benfer, Ray and Betsy Benner, Teresa Berger, Robert Bickhart, Charlie Bickhart, Dick Bilger, Mary Bogar, Carolyn Burns, Brenda Campbell, Community Banks staff, Brendan Cornwell, John Deppen, Doug Eaton, Homer Ernst, Charles K. Fasold, Leon Fetterolf, Joe Fopeano, Dave Garman, Rudy Gelnett, Lonnie Groce, Betty Harmon, John and Dueressa Hassinger, Bud and Ruth Herman, Ted Herman, Alice Herrold, Donnie and Rose Hinckley, June Hoke, Tiffany Howe, Ethel Ann Jones, Tanna Kasperowicz, Kevin Kearns, Helen Keiser, Jim Keiser, Norman Kline, LaRue Knepp, Lee Knepp, Edith Landis, Mary Laudenslager, Erin Loftus, Maureen McDonald, Lorraine Meadows, Gibby Mease, Barry Miller, Dale Miller, Ken Miller, Lester Mitterling, Harvey P. Murray Jr., Carol Norman, Ron Nornhold, Chuck Oberdorf, Mimi Oberdorf, Joan Phelps, Jerry Rhoads, Dave Richards, Ruth Roush, Grant and Mary Lou Rowe, Polly Savidge, Jane Schnure, Norm Showers, Jim Skinner, Howard and Ruth Smith, Pat Smith, Richard Snook, John Snyder, Bob Soper, Gracie Stevenson, Mark Troup, Dave Troutman, Caralyn VanHorn, Jennifer Villeneuve, Mildred Wagner, Bob Walker, Gene Walter, Beth Weader, Bill and Mary Ann Weader, George Wilhour, Carl Winey, Bob Yerger, and Jim Youngman.

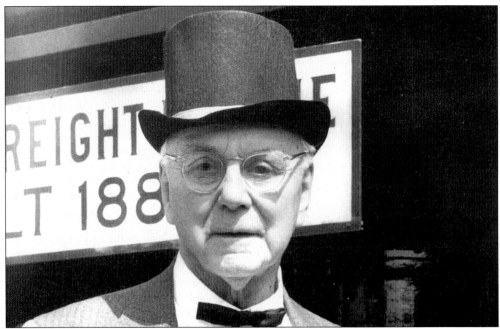

William M. "Billy" Schnure devoted much of his life to historical matters. He was at the initial meeting of the Snyder County Historical Society on Thursday, October 16, 1913, and was appointed secretary-treasurer, eventually becoming vice president. He is pictured here before a train that he was instrumental in scheduling for a trip from Selinsgrove to Lewistown in conjunction with the borough centennial in 1953.

INTRODUCTION

Tracing the origins and evolution of Snyder County is somewhat akin to tracing your own genealogy. Snyder County has something of a family tree. Back in the day of William Penn, Pennsylvania (Penn's Woods—as Latin students of "Miss Phoebe" Herman know) was composed of just three counties: Philadelphia, Bucks, and Chester. They covered an area much larger than the present-day counties of the same names, virtually the entire state when Pennsylvania was laid out in 1682.

Eventually, there were other counties. In this region in 1772, Northumberland County was formed from parts of Lancaster, Cumberland, Berks, and Northampton counties. Prior to that, in 1768, what is now the land of Snyder County was known as Penn Township, Cumberland County. Union County was taken from part of Northumberland County in 1813. Then in 1855, Snyder County was created from the lower portion of Union County. Lycoming County is the commonwealth's largest county at 1,215 square miles, while only four counties are smaller than Snyder. They are: Montour (130 square miles), Philadelphia (135), Delaware (185), and neighboring Union (318).

The 329 square miles that are home to so many of us are fitted in between 40 degrees and 41 degrees north latitude and 76 degrees and 77 degrees west longitude.

A quirk in the southern boundary has an interesting bit of Snyder County folklore attached to it. In the Richfield area, you can leave, enter, leave, and re-enter Snyder County several times within a short distance. According to local legend, one hot summer day the surveyors were lured to a certain distillery in the area, and as applejack was a tasty favorite of the time, the surveyors returned several times to partake of the liquid refreshment, thus the irregular boundary line along the Snyder and Juniata border.

In his seminal 1948 *The Story of Snyder County*, Dr. George F. Dunkelberger, whose work provided a wealth of information for this volume, mentioned that agriculture was the backbone of the county. To back that up, 1950 census figures show that there were 1,742 working farms within Snyder County.

Dr. Dunkelberger further stated that our area was first settled in 1745—before the territory was officially opened—predominantly by the Pennsylvania Dutch. More correctly, these early settlers were Pennsylvania German, although they did pass through Holland on their way to English ports, wherefrom they eventually sailed to America in their quest for religious and other freedoms.

There have been many events that have shaped Snyder County's heritage: the French and Indian Wars (the Penns Creek Massacre occurred in 1755); the Revolutionary War; Snyder County resident Simon Snyder's (for whom the county is named) three terms as governor (1808–1817); the Pennsylvania Canal system; the Civil War; the Industrial Age; and more recent wars. Each has left its mark.

Perhaps the most far-reaching influence was Governor Snyder's concern for education. He was an early advocate of public schools and was governor in 1809 when an act for educating the poor was passed. Public education was expanded later. Today it is possible to go from kindergarten through college (Susquehanna University) without leaving the county.

While the county is rural in nature, it is neither isolated nor remote. The major cities of the eastern seaboard are within easy reach. Many county residents take full advantage of our central location. At the same time, Snyder County has much that the more populous areas do not, including pastoral settings; abundant areas for hunting, fishing, and other outdoor recreational activities; rivers and creeks, lakes and ponds; and historical points of interest.

One of the county's main resources is its hardworking and industrious work force. For many years, small businesses and factories have been kept humming at top efficiency by conscientious and reliable employees.

The county is one of relatively few that can still boast of a stand of virgin forest like that of Tall Timbers, located in Snyder-Middleswarth State Park in the Troxelville area.

An early automobile, the Kearns, was built in Beavertown at about the time Henry Ford began mass-producing Ford motor cars. Fruit farms flourished and in 1913, the Snyder County Fruit Growers Association was formed. Tobacco was also raised until recently on county farms. Port Trevorton was an important shipping terminal for anthracite coal that was deep-mined on the other side of the Susquehanna River. Today, more modern businesses add to the economic picture of the county.

While Snyder County is typical of Pennsylvania's upstate rural counties in many ways, it is also quite unique—just ask anyone who has spent time within its boundaries.

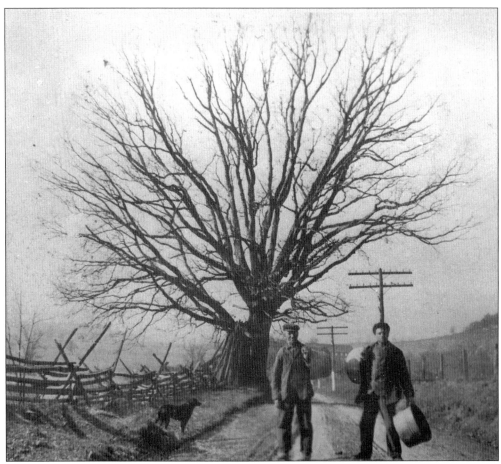

The following caption appeared in the Thursday, March 20, 1924 *Middleburg Post:* "Snyder County lost one of its oldest landmarks in the removal of the giant white oak tree on the Kemer C. Walter farm three miles west of Middleburg. The tree, which measured a little over seven feet across the stump, was cut down by John A. Painter, State road foreman and his gang of men, and N. Guy Brookhart, lineman for the Middlecreek Valley Telephone Co. The tree was the largest oak in Snyder County."

One

DOWN ON THE FARM

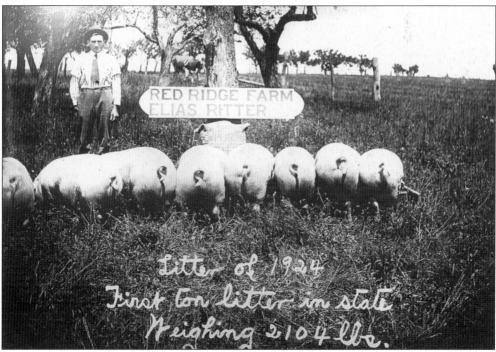

When Dr. George F. Dunkelberger wrote his seminal work, *The Story of Snyder County*, in 1948, he stated—accurately—that the main business of Snyder County was agriculture. Development has bumped agriculture from the top spot, but it is still significant today. Typical of those who made agriculture important was Elias Ritter, who farmed in the Kratzerville area. He proudly displays his eight hogs from a 1924 litter. The eight grew heavy enough to reach a total weight of more than one ton.

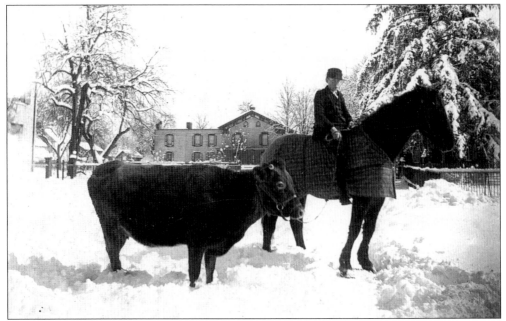

All over Snyder County before the turn of the 20th century, youngsters tended to raise livestock that were as much pets as necessities to the subsistence of the family. As 4-H members do today, the young men and women of another era took great pride in their animals. Shown astride his horse, another important animal in those pre-auto days, is J. Howard Burns of Selinsgrove, with his prize steer.

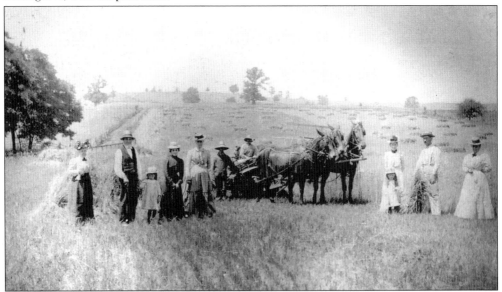

Selinsgrove photographer Reuben Ulrich took this 1898 photograph at his farm, where the Catholic church is now located. Identification was provided by Marion Moyer Potteiger, the little girl standing in front of the woman third from the right. Pictured from left to right are Izora Ulrich, George G. Ulrich, Cordilla Moyer, Effie Breimeier, Elvida Snyder (the farmer's wife), unidentified, Allen Snyder (the farmer), Lizzie Moyer, Marion Moyer (in front), William Moyer, and Lura Ulrich (the photographer's wife).

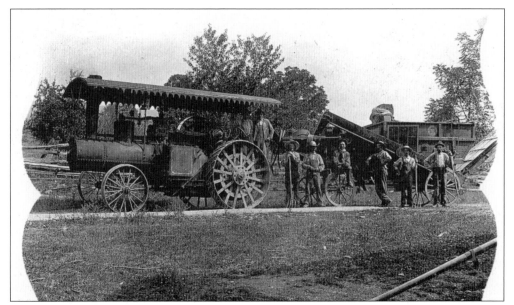

Before the internal combustion engine, huge steam engines were used to make agriculture a less arduous task. Pictured in Beaver Springs in 1905 is a monster steam engine with a harvesting device behind it. There is no doubt the men posing with the machinery are pleased not to have to use their hand tools—pitchforks, mostly—to do *all* of the work. With a small number of steam engines in existence, the few tended to make the rounds of area farms during the harvesting season.

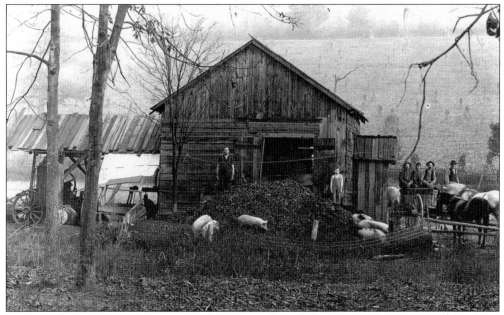

To a city slicker such as the author, at first glance this appears to be a photograph of a pig farm. However, someone in the know pointed out that it is the cider press in McClure, at the location of a later locker plant. With Snyder County's many orchards, several cider presses did a robust seasonal business. To the left is the apparatus used in cider making. To the right are a wagon with workers and the team of another wagonload of apples. Six pigs are enjoying a treat of processed apples.

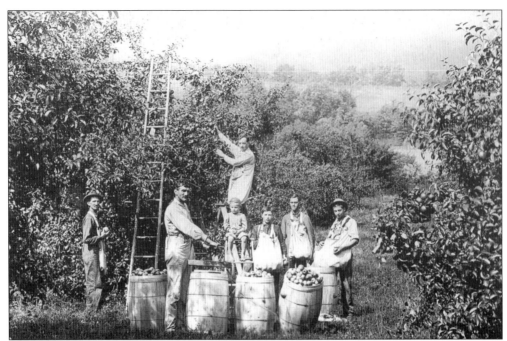

There are Washington State apples, and then there are Snyder County apples. Many prefer the closer-to-home variety. Over the years, many Snyder County families have been involved with orchards and the growing and marketing of fruit. Among the names that come to mind are Sierer, Mitterling, Trexler, and Boyer. Shown is the Boyer family, c. 1919, harvesting apples on their Mount Pleasant Mills area farm. The work force seems to comprise the entire family.

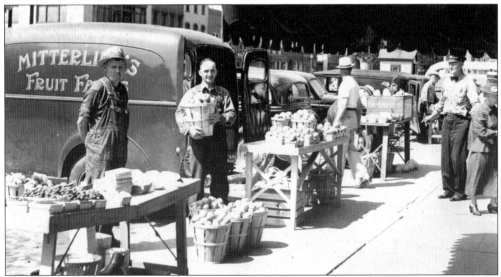

Snyder County was, and is, engaged in extensive fruit growing. For many years, the Mitterling name has been associated with fruit, especially apples, in the Mount Pleasant Mills area. Pictured at the rear of his 1937 panel truck is John T. Mitterling offering the fruits of his labor at the Sunbury Curb Market in this 1939 photograph. Most recently Lester Mitterling headed the business. Mitterling apples won more than 50 awards at the State Farm Show in Harrisburg. The business closed on May 7, 2004.

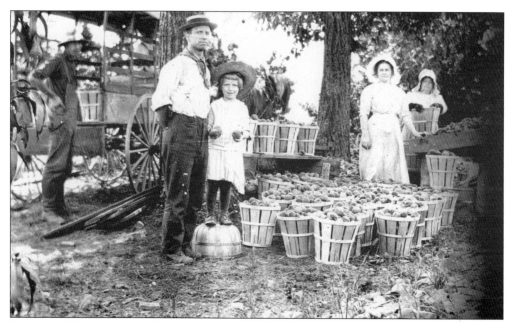

Fruit orchards are still a big business in Snyder County. The neatly spaced rows of fruit-bearing trees still dot the county's landscape. Apples are the most prevalent crop, but not the only crop. Here in the early 1900s, a family proudly shows the recent peach harvest from a Freeburg-area orchard. Note the prideful look of the little girl standing on an upturned bushel basket as she displays her handfuls of peaches.

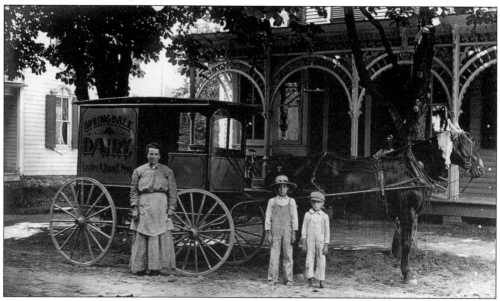

Many early Snyder County families had their own cow. But as towns grew, deliveries by the milkman became more commonplace. Most towns had at least one dairy that made the rounds. One such operation was the Springdale Dairy in the Beaver Springs area, c. 1905. The proprietor was Lester A. Troxell. Bottles from the local dairies have become quite collectible. Recently, a single bottle from the C. W. Troup Dairy in the Mount Pleasant Mills area fetched close to $1,400 at auction.

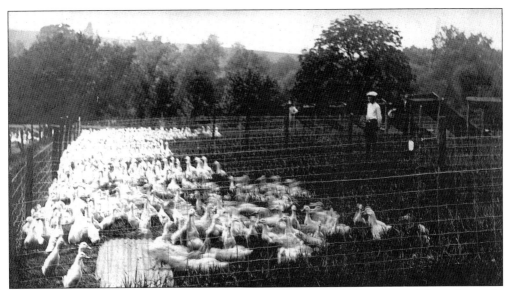

Farming in Snyder County took on many forms. There were crops that sprouted from the earth, and there were those that walked on it. One of the largest duck farms in the county was the one pictured here, located at Kantz. This particular group of webfeet was photographed in the 1920s. While many of the ducks found their way—unwillingly, we assume—to the dining room table, others were spared, if only temporarily.

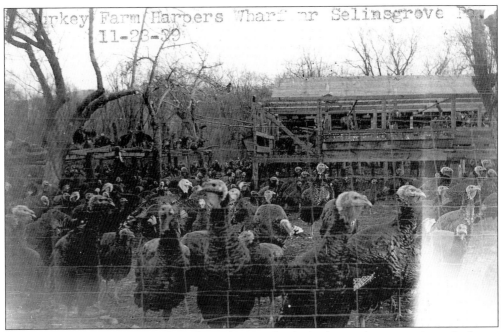

It is hard to say whether the turkeys shown here or the ducks shown above constitute the larger flock. Both are quite numerous. We are grateful for the typed information on the photograph, but it was undoubtedly provided by someone not native to Snyder County. While it is nice to know the date, Thursday, November 23, 1939—ironically, Thanksgiving Day—the identification of Hummels Wharf as Harpers Wharf does not sit well with county residents.

14

Two
BUSINESS, INDUSTRY, AND COMMERCE

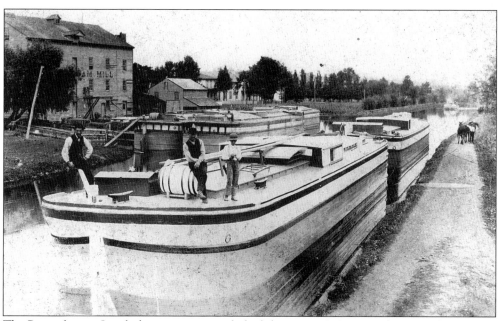

The Pennsylvania Canal, the construction of which began in 1827, was truly a marvel of its time when it was finally completed in 1832. Countless tonnage was moved by the "big dig" and its system of locks. This 1885 photograph is perhaps the finest and sharpest picture of just what a canal boat was and how it operated. These particular barges are passing the Shamokin Dam Mill, which is no longer in existence. Note the mules on the towpath and other boats docked near the mill.

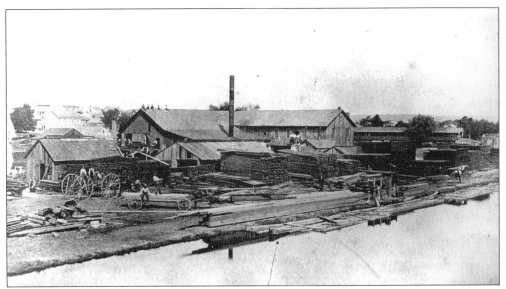

Before the canal can be of much service to the surrounding area, there have to be canal boats. Boats, which were designed more like barges to hold as much cargo as possible, were built at many locations along the canal route. Shown in 1885 is the Culsher & Moyer Lumber Company on the Isle of Que, just south of the covered bridge that linked Selinsgrove to "the island." The golden age of railroading hurt the canal system, and by 1901 the last barge had floated through Selinsgrove.

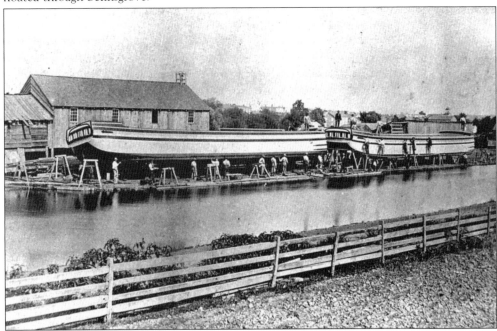

The actual construction of a canal boat was quite an undertaking in an era of mostly hand tools. Shown is another view of Selinsgrove's Culsher & Moyer Lumber Company in 1885. To judge the size of the canal boats, notice how they dwarf the dozen or so men working on the boats. The typical boat was 80 feet long, 14 feet wide, and 8.5 feet high. Is it any wonder that the shoes of someone with rather large feet were referred to as canal boats?

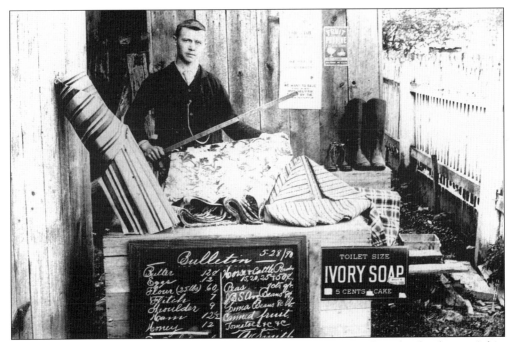

Store clerk James B. Spangler proudly displays his wares in this 1890 photograph taken at Adam Smith's Beaver Springs store. The Smith store building was later occupied by a store owned by Paul Gross. Perhaps the most interesting aspect of the photograph is the price of the various items, for example: butter was 12¢ a pound and milk cost 12¢ a quart. Ivory soap, though now more than "5 cents a cake," is still on the market today.

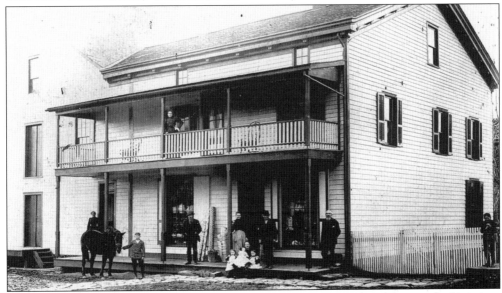

For years, Sheetz's store on the Isle of Que was a Selinsgrove institution. But the store had its origin in the late 1800s (this photograph was taken in 1897), and was owned by James K. Burns. Burns is at the right of the lower porch, Jesse Burns is on the second-floor porch, and J. Howard Burns is with the horse. Mary Burns, with two children and a doll, is seated in front. In 1972, tropical storm Agnes forced the closing of Sheetz's, which was purchased from the Boyer family on July 21, 1936.

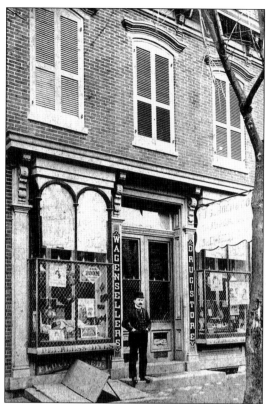

Sharing space in this 1884 photograph are the Wagenseller Drug Store and F. J. Schoch & Company's store of Selinsgrove. The Schoch store dealt in such diverse items as flour, feed, coal, salt, and seeds. The photograph of these stores is thought to be the oldest merchant photograph of Selinsgrove. Standing outside the store is perhaps George Wagenseller, proprietor, or simply a "drug store cowboy." Lytle's, Cott's, and Cole's were subsequent drug stores. Bot's Café is presently located at the Market Street site.

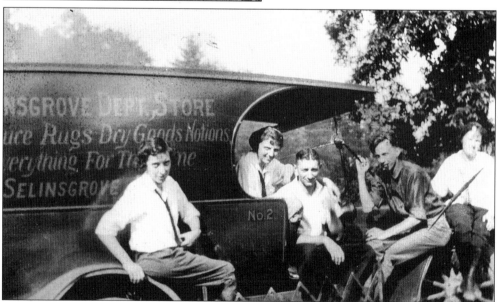

Long before the Susquehanna Valley Mall, there were many mom-and-pop stores in Snyder County's towns and villages, and a few larger businesses calling themselves department stores. Pictured in 1921 is a group of Selinsgrove Department Store employees. The only one identifiable is Harry Row, seen third from the left. The store's motto (see truck lettering) could be, "If we don't have it, you don't need it."

Steffen's Store, shown here in the early 1940s, was just one of many smaller grocery stores in Selinsgrove. Pictured from left to right are clerk Mabel Forster, an unidentified customer, and proprietor Marand E. "Randy" Steffen. Some of the items shown are still available today—Coca-Cola, Cut-Rite wax paper, etc. Russell Learn later operated a similar business at the location for many years. The site is now occupied by the Selinsgrove Sub Shop.

Opened in 1922, the business that was known as Reichley's Candy & Soda Shoppe was a mecca for local youth for decades. The shop later became known as Taylor's, then as Hill's. The homemade candy and ice cream and the soda fountain were almost as big a draw as the Wurlitzer jukebox and the dance floor. Youth ranging in age from junior high to college congregated at the North Market Street confectionery. Shown behind the counter is Maryanne Reichley, daughter of owners Fred and Edith Reichley.

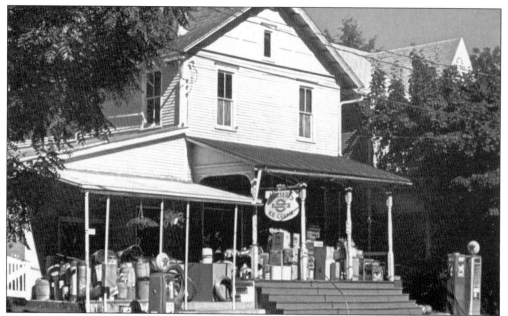

When it was built in 1891, this general store in Kantz was one of dozens in the county. From 1936 to 1980, the store was owned by the Musser family. If you mentioned Charlie Musser's, nearly everyone knew what you meant. It was one of the last truly general stores to exist, and it catered to many of the area's Amish and Mennonite families. Missing from the photograph are the numerous carriers of empty Pepsi bottles that usually occupied a substantial portion of the steps.

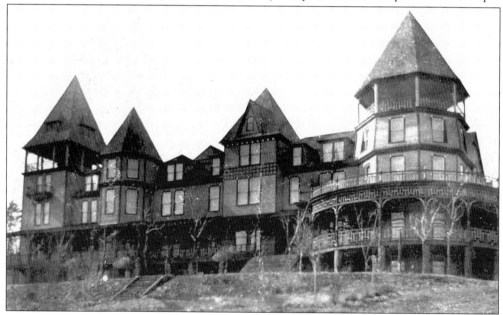

The magnificent Hotel Shikellamy, perched high atop Blue Hill in the Shamokin Dam area, commanded an outstanding view of the confluence of the north and west branches of the Susquehanna River and the surrounding area. Constructed of wood in 1893, the hotel was unfortunately destroyed by fire on Wednesday, May 4, 1898. This photograph dates back to 1895. Tedd's on the Hill exists today near the site and offers the same outstanding view and quality food.

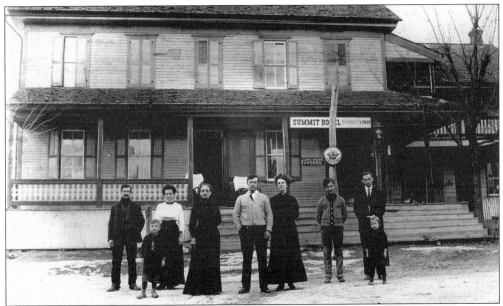

According to information on the back of this photograph of the Summit Hotel taken by Bert VanHorn in 1908, those pictured here are, from left to right, Norris VanHorn, Tal VanHorn, Mamie VanHorn, Lucie VanHorn, Floyd VanHorn, Mrs. Floyd VanHorn, Lawrence VanHorn, Clayton Kratzer, and Beulah VanHorn. The Summit, which is no longer standing, should not be confused with another hotel that shared space on Shade Mountain—the Shade Mountain Inn.

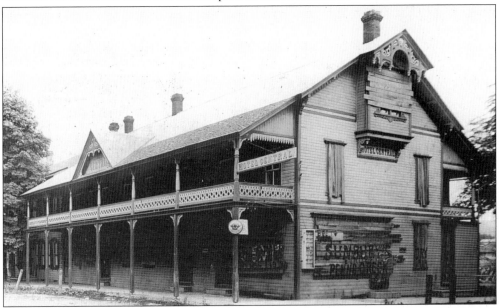

Originally, the Hotel Central (shown c. 1919) was located at the main intersection in Middleburg. This building later became a store. One of several proprietors was Harry E. Emery, who owned the property from the 1940s to the 1970s. The store stocked many items, but Ron Nornhold, who is the great-great-grandson of Emery, remembers mostly the fresh roasted peanuts and penny candy. He also recalls viewing Halloween parades from the second-story balcony—"the best possible place to watch."

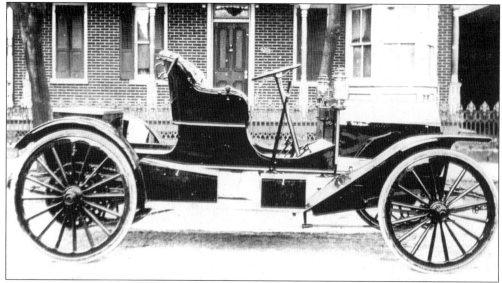

At the turn of the 20th century, John P. Kearns had a flourishing buggy- and wagon-building business on Center Street in Beavertown. Then the automobile age dawned, and Kearns was one of more than 2,500 makers of American autos. Three U.S. automakers are left today. The early Kearns—a 1907 model is shown here—had solid tires and an 84-inch wheelbase. Those sold in the United States were delivered by Kearns personally, so he could provide driving instruction. Some were exported to England and Europe.

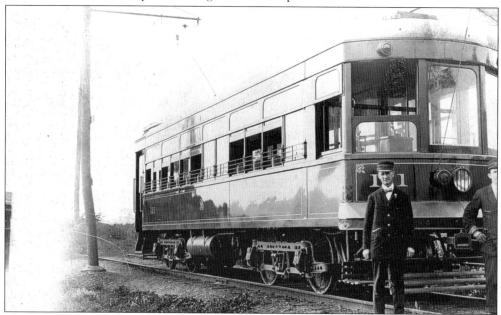

It was first operated in 1907, and was known simply as "the trolley." More formally, it was the Sunbury-Selinsgrove Electric Street Railway, and it provided inexpensive, reliable, and frequent transportation to all communities along the line between Sunbury and Selinsgrove. Edward Hane of Shamokin Dam, thought to be the man mostly visible here, was the motorman on the first trip into Sunbury and the motorman on the last trip on New Year's Eve 1934. The trolley—the county's only one—gave way to BKW Coach Lines.

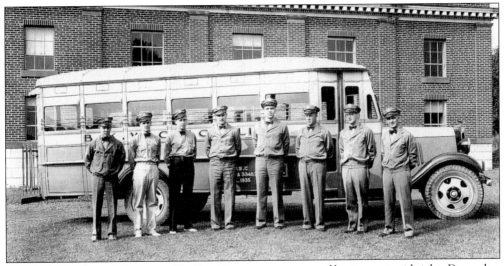

When the Sunbury-Selinsgrove Trolley Company went out of business at midnight, December 31, 1934, BKW (Buffington, Kessler, Wilhour) Coach Line came into existence at 2:00 a.m. on Tuesday, January 1, 1935. Pictured with the first coach—consisting of a $500 Chevrolet chassis and a $1,838 Wayne body—are the original eight drivers, several of whom stayed on for years. From left to right are Clyde "Sammy" Slear, Harry Boyer, Benton "Ben" Anderson, Carl "Dinah" Bittner, Russ Trutt, L. C. Buffington, C. W. "Pappy" Wilhour, and J. P. "Jim" Kessler. Buffington, Kessler, and Wilhour were the principals of BKW.

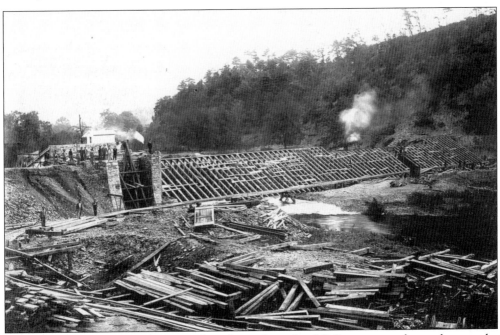

For years the Middle Creek power dam, located south of Selinsgrove and seen here under construction on October 18, 1906, not only provided electrical power, but also created a water reservoir for fishing, boating, and swimming. Only recently has the dam been dismantled and Middle Creek allowed to flow freely. Before it was dismantled, the dam had long since ceased to be a source of power, but not of recreational opportunities.

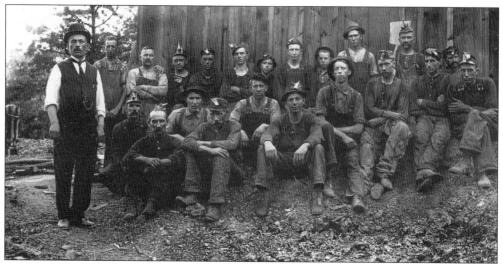

What appears to be a misplaced group of coal miners—note the miners' lamps on caps—is actually a group of Snyder County iron ore workers who mined ore on Shade Mountain, near Beaver Springs. They resided in a camp known as Shawverville, named for Isaac Shawver, on Ner Middleswarth's property. By the winter of 1912–1913, not long after this photograph was taken, it was no longer practical to dig out the rather low-grade ore and operations ceased.

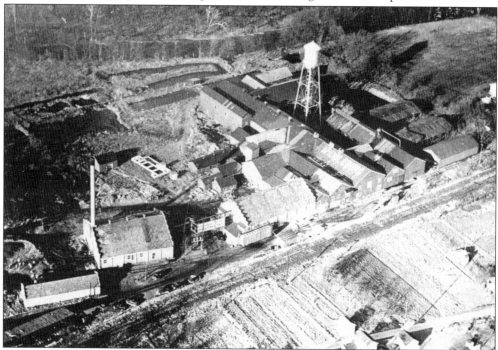

Known as "the tannery," it was Middleburg's first major industry. The specialty of the plant was the tanning of South American hides into sole leather. Many of the Middleburg products were used in making quality Florsheim shoes. The plant's peak output was 220 tanned hides a day. First operated in 1901, the tannery was destroyed by fire in 1967 and was never rebuilt. Jacob Paskusz, a New Yorker, was the plant's first owner. It was later operated by Art May of Selinsgrove, who also served in the Pennsylvania House of Representatives.

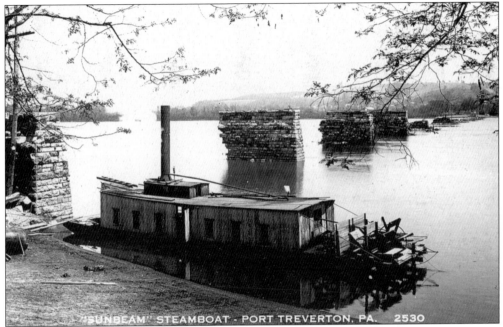

The *Sunbeam* was owned by the Bogar family. The paddle-wheel steamer took passengers and freight between Port Trevorton and Herndon, on the Susquehanna's eastern shore. George Eyer Keller, whose family was long involved in boatbuilding and river operations, is seen piloting the boat in this *c.* 1928 photograph. Piers from a former bridge that was declared unsafe in 1870 form a backdrop. Ferries between Port Trevorton and the eastern shore trace their charters back to the date of the bridge's closure.

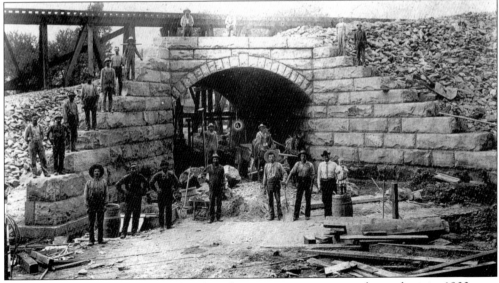

This Sunbury & Lewistown Railroad underpass construction is taking place in 1900 near Pawlings Station in Penn Township on Middlecreek Road. Carpenters built a wooden form to facilitate the stone arch, but much manual labor was needed to set the massive stones. There is no question of the quality of work—the structure still stands, and is used today. Perched atop the arch, at the right, is 12-year-old Harrison Musser, a water boy at the job site.

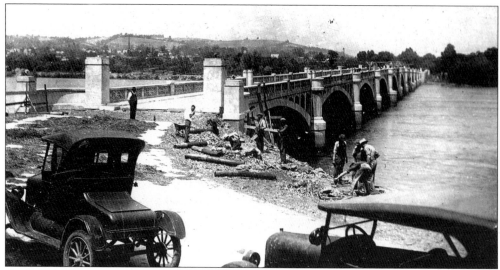

On Sunday, June 13, 1923, a disastrous fire claimed the wooden covered bridge that connected the northeastern part of Snyder County with Northumberland. The state legislature quickly appropriated $350,000 for the construction of what became known as the White Bridge, because of the color of its cement finish. Shown here in the spring of 1926 are workmen putting on the bridge's final touches. With much fanfare, the bridge opened on Friday, July 2, 1926. It was replaced in 1978.

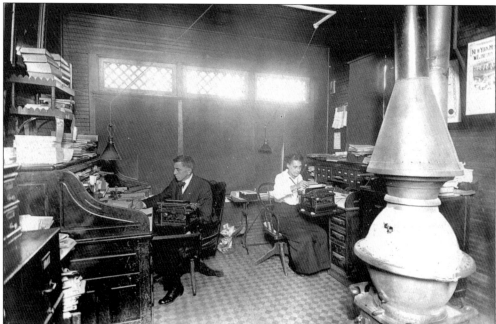

At the time this photograph was taken in 1905, there was no radio, television or Internet. Newspapers were the way most Snyder County residents received their news. Shown is the editorial room of the *Middleburg Post*. At the typewriter on the left is editor/publisher George Wagenseller, a venerated figure in the development of Snyder County and the historical society. At the other typewriter is editorial assistant Clara Winey, a longtime and faithful employee of the newspaper.

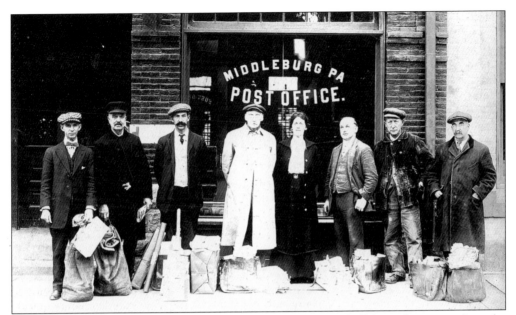

"Neither rain, nor hail, nor sleet, nor snow, nor dark of night shall keep this carrier from the swift completion of his [or her] appointed rounds." That oft-quoted motto of the United States Postal Service had its origin in 1876, when William Kendall of the Boston post office translated an ancient Greek poem. These Middleburg carriers were photographed in 1914 as they were about to set off on their appointed rounds. From left to right are William Gutelius, Joe Musser, Ira VanHorn, Cal Schoch, Mabel Wetzel, John Brosius, William Snyder, and Art Beaver.

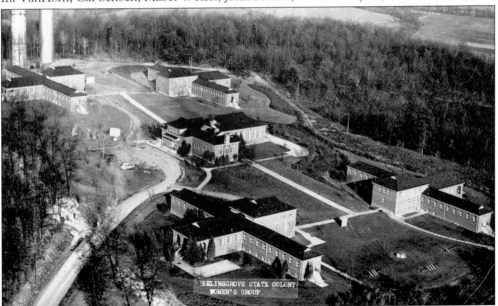

Known variously as the State Colony, the State School, and now the Selinsgrove Center, this facility was opened on Friday, August 9, 1929, as a retreat for epileptics. It has been a major Snyder County employer over the years. This late-1930s aerial view depicts the Women's Group and other original buildings. The number of patients peaked in the 1970s, but state policy has now reduced "the center" considerably.

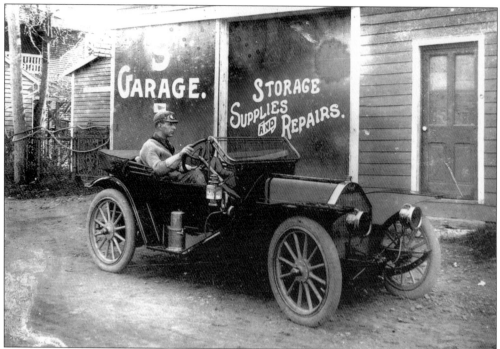

At the dawn of the automobile age, astute businessmen took advantage of what the horseless carriage could add to the daily economy. The "S" Garage, located at Walnut Street (now University Avenue) and the alley behind the current post office, was one of the first such businesses in the county. It was operated by George "Yarrick" Schoch, seen here at the wheel of a sporty 1912-model auto. At first, garages were simply storage facilities, but they later branched out into repairs and other services.

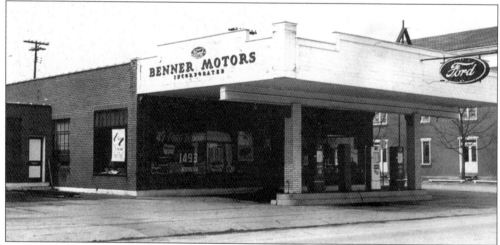

For four generations, the Benner family and Fords have been synonymous in Selinsgrove. The family's first business location was at the corner of Market and Mill Streets. This photograph, taken in 1948, reveals that the 1949 Ford Tudor model is available and priced to move out at a low, low $1,493. From this modest operation, Selinsgrove Motors moved to a spacious and modern location at the junction of Routes 522 and 11 and 15 on North Market Street. Becker Volkswagen later began in the vacated building. Fisher Auto Parts currently occupies the site.

Which came first? The chicken or the egg or the mill or the town? Globe Mills, shown here in an 1894 photograph, is located in the village of Meiser, but the other village just across Middle Creek undoubtedly took its name from the three-story brick roller mill, then owned by S. H. Yoder. The sturdy brick building still exists, but the signage now identifies it as the Pine Meadow Chinchilla Ranch.

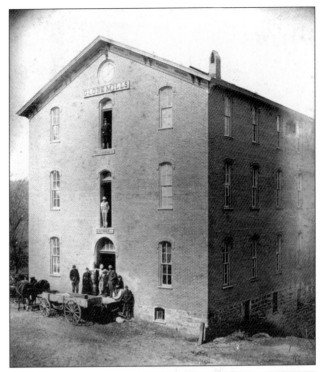

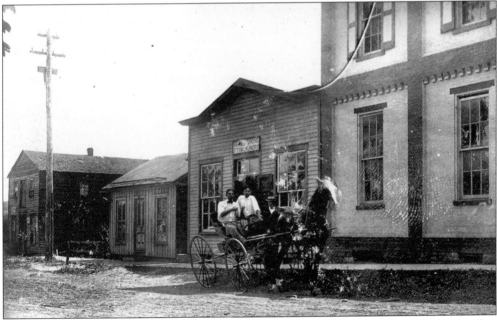

Pictured here c. 1907 are two unidentified youths in a stylish horse and buggy, plus a rather dapper onlooker. Also significant are the buildings in this view of East Pine Street in Selinsgrove. Seen are the Selinsgrove Steam Laundry, owned at the time by George Fisher, who sold it to Harry Fasold in 1915, and the not-so-easily recognized Ulrich photograph studio, owned by Reuben L. Ulrich. Close inspection will reveal many photographs on display in the studio windows.

A quick glance at this McClure worker and his handiwork may not let you detect the true nature of what you see. It takes a closer look to reveal that the huge stack of material is actually composed of thousands of wooden barrel staves—carefully shaped pieces that will make up a barrel when fitted together and hooped. In a truly practical application, many staves are placed inside of a loosely wired barrel for shipping. The person in this 1911 photograph is thought to be Ralph Howell.

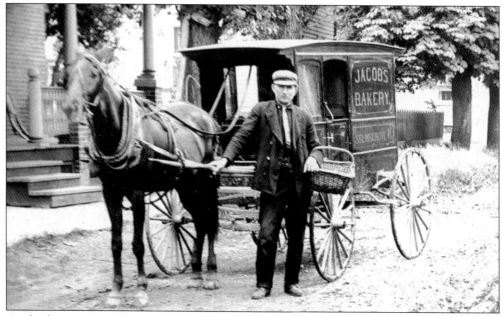

At the beginning of the 20th century, many Snyder County residents still baked their own bread. Those who did not could count on the local bakery to delivery fresh bread daily. Typical of many bakeries was Jacob's Bakery of Selinsgrove. Advertising in the 1910 *Lanthorn* (Susquehanna University's yearbook), Jacob promised, "Send in an order, and it will be delivered free." It is assumed that this is Jacob making such a free delivery at about the time of the yearbook advertisement.

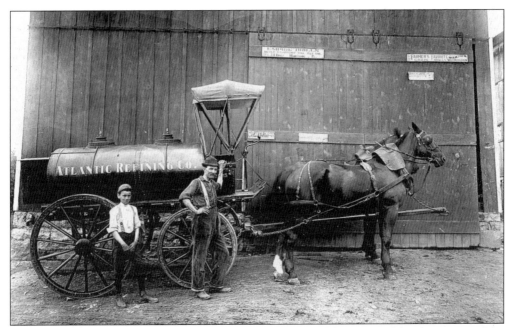

What is known today as ARCO (short for Atlantic-Richfield Company) has been around for over a century. For years, it was Atlantic Refining Company. This early-1900s horse-drawn rig was owned by J. F. Reitz of Middleburg. The man and boy in the photograph could be Reitz and his son. The wagon was used for home deliveries.

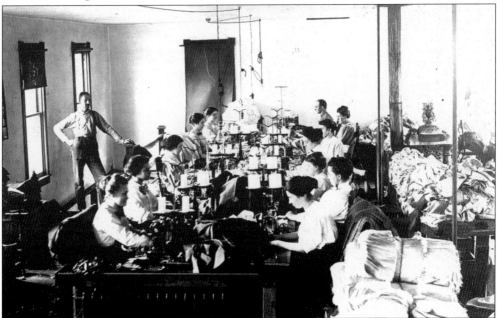

Many Snyder County towns had at least one factory that supplied product to the textile industry. Pictured is a group of seamstresses working in what is believed to be the forerunner to the Charles Saylor Shirt Factory prior to World War I. Saylor factories operated in both Beavertown and Beaver Springs. The first plant opened in 1911, not long before this photograph was taken. At its peak, Saylor employed close to 100 full-time employees.

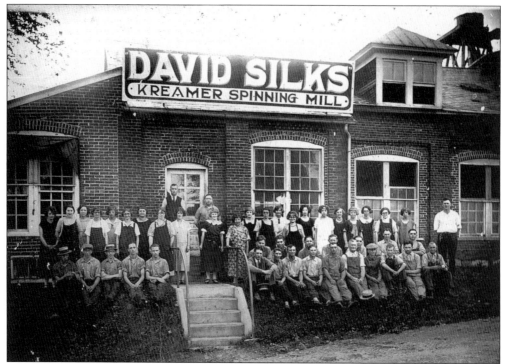

Textiles played an important part in the development of Snyder County. Shirt factories, as seen elsewhere, were common. Not as common were silk mills. David Silks's Kreamer Spinning Mill was one. The business opened on Monday, February 4, 1924. Shown here is the work force of 1926. The silk mill—no longer producing at the time—was part of Wood-Mode's expansion in the 1950s.

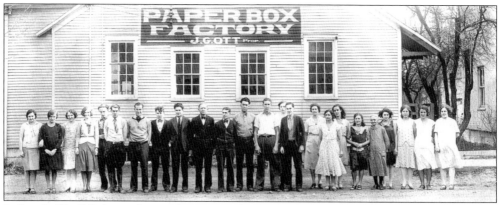

J. Grieth "Griffy" Ott took over the existing business of Percy Herman in the late 1920s, and began Ott Packagings at the Water Street, Selinsgrove location. The workers pictured here c. 1930 are, from left to right, E. Mincemoyer, J. Knouse, S. Brown, M. Oberlin, E. Swope, O. Stauffer, R. Bolig, B. Bressler, A. Soper, Ott, A. Wise, C. Hoot, G. Wilt, M. Bolig, C. Knouse, N. Bickhart, unidentified, A. Swope, M. Miller, A. Erdley, H. Walborn, two unidentified women, and V. Hartley.

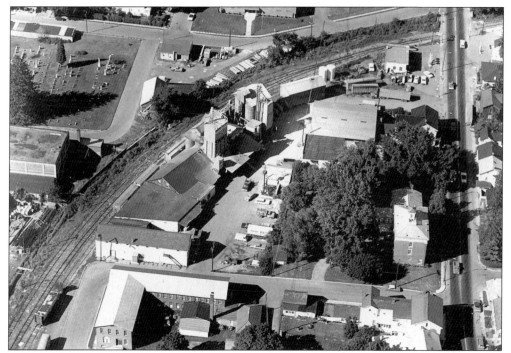

For many years Rhoads's Mill in Selinsgrove was operated by the family of Simon Rhoads—first, his father and then his sons. It was only recently that the mill closed. This 1960 aerial photograph shows the mill complex and the railroad that served it. Note several rail cars on a siding. A generation of youngsters found the mill an enticing venue for weekend games of "Cowboys and Indians" and other recreational pursuits. Like several county businesses, the mill survived several fires.

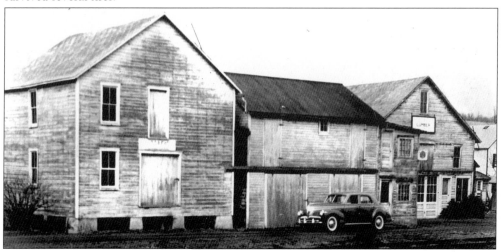

Wood-Mode, "America's preeminent maker of custom kitchen cabinetry," had rather humble beginnings. In 1942, known then as Wood-Metal, the firm purchased Harry S. Kreamer's planing mill, shown here, in Kreamer. World War II took the metal out of Wood-Metal, but government contracts for shell cases, radio cabinets, desks, ladders, and even carrier-pigeon cages sustained the young company. Today Wood-Mode is not only an industry leader, but also a major employer of Snyder County workers—2,000 at present.

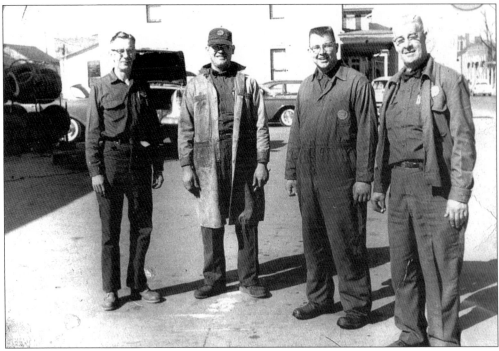

Service stations, especially those well run and reliable—like Troutman's Gulf Service at Market and Sassafrass Streets in Selinsgrove (now a Coastal Mart)—become local landmarks. Taking over from Iva Leach in 1948, G. Lawrence Troutman, with help from sons Bob and Dave, enjoyed the confidence of all who stopped by the station. Pictured in 1960 are, from left to right, Lee Stephens, Bob, Dave, and "G.L. Troutman, owner," as a sign over the door stated.

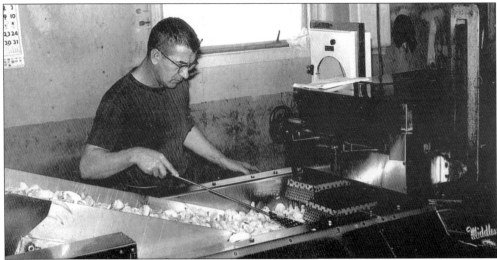

The first batch of Middleswarth Potato Chips was made in February 1942 in a barn behind the family home on Market Street in Beavertown. When Ira and Lottie Middleswarth founded the company, they employed four people and made 15 pounds of chips per hour. The company moved to Middleburg in 1948. Further expansion pushed production to 3,500 pounds per hour, helped by 70 employees. In this 1950s photograph, James W. "Sonny" Herman Jr. checks chips coming out of a fryer.

Three

OUR TOWN

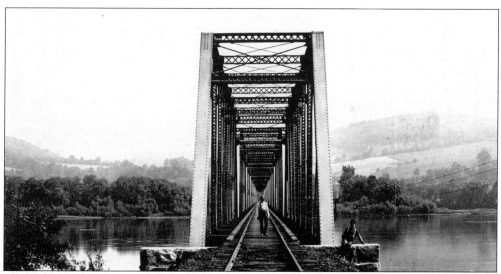

A favorite stage play is Thornton Wilder's *Our Town*. It depicts life in small-town America from 1901–1911, an era represented by many photographs in this and other chapters. Seen in this interesting display of perspective is the railroad bridge in Selinsgrove. The photograph was taken on June 6, 1908. The bridge is nearly a mile long, but the steel framework seems to fade into oblivion. For the sake of the man on the tracks, it is hoped the next train is not due for quite some time.

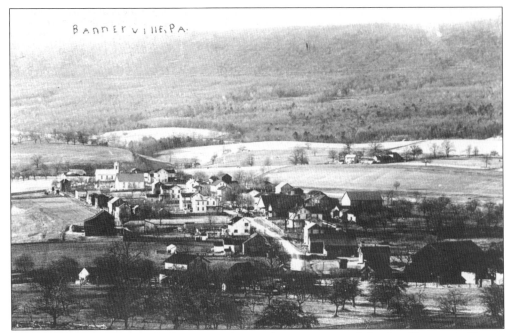

Bannerville is a village tucked away in the southwestern part of Snyder County in Beaver Township. This 1907 photograph shows the town's frame residences, outbuildings, and church. Jack's Mountain provides the backdrop. When a writer asked for a better or different photograph, Ron Nornhold said, "Better take it. It's the only one you'll find."

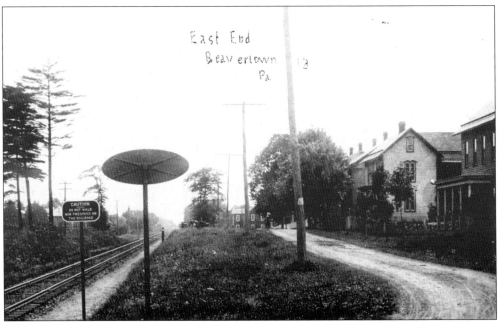

Shown here is the east end of Beavertown as it appeared in 1903. Too many people found out the hard way that pedestrians and buggies were no match for an oncoming locomotive. As a precaution—see the sign in the foreground—the Sunbury-Lewistown Railroad warned all, "Do not walk nor trespass on the railroad."

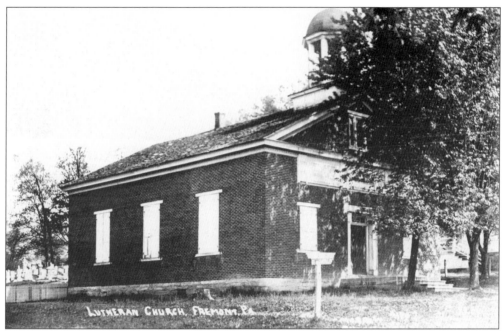

The churches of Snyder County were vital in the development of the area. They offered spiritual nurturing and, in many instances, social activities. The Fremont Lutheran Church—now St. John's—is pictured in the early part of the 20th century. The structure is typical of such houses of worship. The photograph was taken by Morrow of Newport (in nearby Perry County).

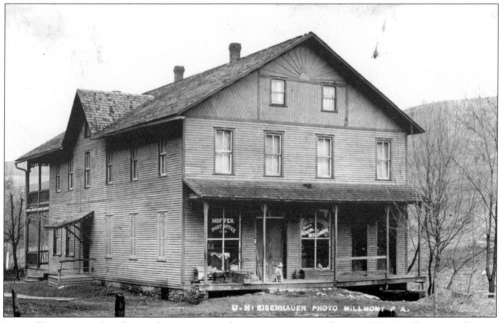

Post offices were often housed in stores, and some even in residences. The Hoffer post office in Chapman Township shared space with W. B. Rine's establishment, Dealer in General Merchandise. It is not known if the faithful canine on the porch is a security measure or waiting for a Rine's customer. This U. H. Eisenhauer photograph is 1908 vintage.

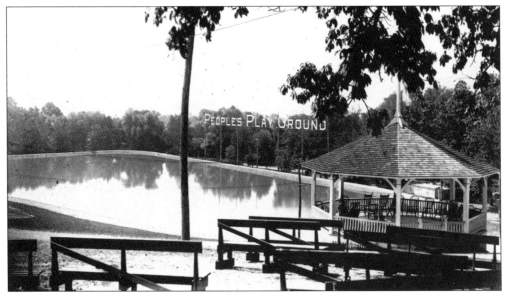

Rolling Green Park, or "the Peoples Playground," in Hummels Wharf was the source of fond memories for thousands of Snyder County residents from its opening in 1908 until its closing in 1972. Land was purchased from Philip Teats for $9,841.66. Picnic groves, an arcade, a dance pavilion, a lake for boating and later rides, a swimming pool, and a theater drew large crowds. The park's other motto was "Fifty Ways for Fun." This photograph dates from around the time of the park's opening.

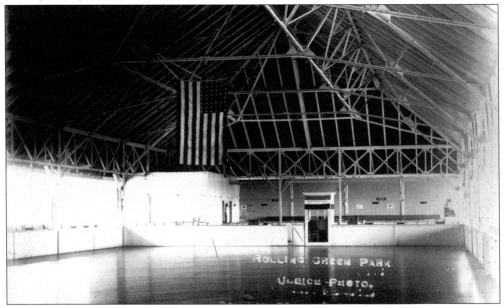

"Green Dances" is a phrase that invokes nostalgia in generations of Snyder County residents. The dance pavilion at Rolling Green Park—shown here in a 1908 Ulrich photograph—served long and well. It opened for its first dance on Saturday, July 25, 1908. According to John W. Bittinger, music was provided by Joe Nesbitt & His 10 Pennsylvanians. Later, Tommy Dorsey, Fletcher Henderson, Wayne King "the Waltz King," and Buddy Rogers played for dances at "the Green."

The general store of Brian Teats in Hummels Wharf, on the Old Trail in the vicinity of Park Road, stood for years. The proprietor and his best friend are pictured in this 1921 photograph. In addition to dry goods and notions, filtered gasoline was dispensed at 14¢ a gallon! The tobacco sign proclaims its product to be the best for smoking or chewing, but it is too faded for the advertised brand to be determined.

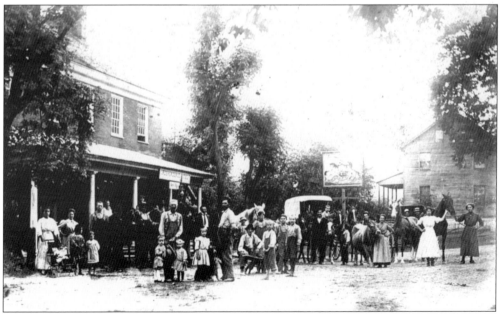

Independence is another small town along the Susquehanna Trail (Routes 11 and 15) in eastern Snyder County. This is a c. 1904 photograph of the Independence Hotel. Judging from the number of people shown, it seems the entire town turned out, including several horses, a dog, and one cow. Note the rather elaborate hotel sign with the Pennsylvania coat of arms.

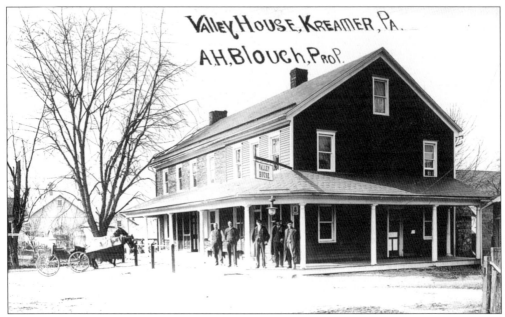

Beginning in 1822, the Valley House in Kreamer was a beacon to weary travelers. It was a stagecoach stop that evolved into a full-fledged hotel. You can still enjoy a tasty meal and slake your thirst there. Shown in the first decade of the 20th century, the exterior has since undergone several facelifts, but the basic structure—stone walls measuring one and a half feet thick—is as it was almost 200 years ago.

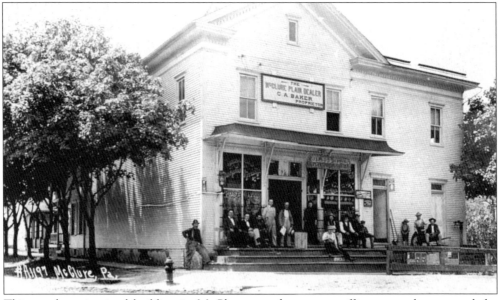

This neatly maintained building in McClure served as a post office, general store, and the offices of the McClure *Plain Dealer*. The longstanding weekly newspaper was published by the Baker family for years. At the time of this 1908 picture it was published by Cluny Arthur Baker. While a few people in the gathering are the newspaper's staff, it is obvious that all present were welcome to be part of the picture. Note the fire hydrant to the left, the design of which has not changed in years.

Traveling north on Routes 11 and 15, you come upon one of the most scenic spots in Snyder County. While still attractive, the face of McKees Half Falls has been changed by the widening of the Susquehanna Trail. Photographer J. M. Rine captured the site's natural beauty as it appeared in 1906. Notes on the back of the photograph indicate Rine was ordering 1,000 postcards of the scene. Note the young man contemplating at water's edge.

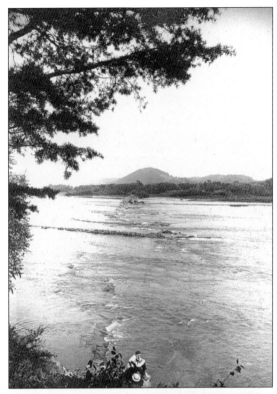

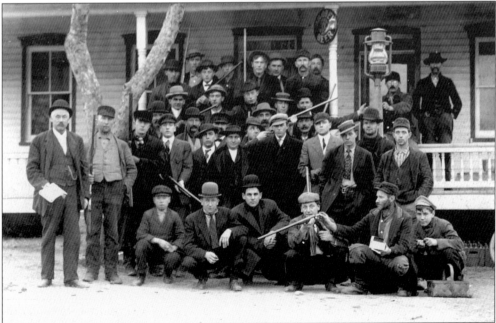

Thanks to a recent ESPN promotion, we are reminded that nimrod is not a derogatory term, although it is still used as such. Webster defines *nimrod* as "a skilled hunter." Shown here, in 1911, on the front porch of the Meiserville Hotel is a large group of nimrods—some with their choice of weaponry, others in stylish derby hats.

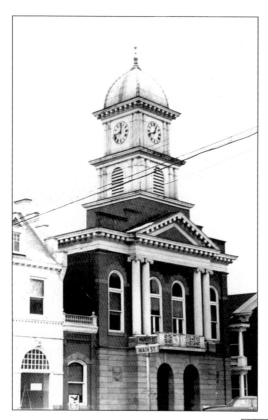

The hub of any county is the county seat, which for Snyder County is Middleburg. The center of much of the activity in Middleburg is the courthouse. Cases are heard there and county row offices are located there. This is the courthouse as it appeared c. 1950. The original courthouse was deemed not to be fireproof in 1865, and a new courthouse and jail were built. Extensive renovation work was also done in 1976–1978. The core of the 1865 building is still a part of the present courthouse.

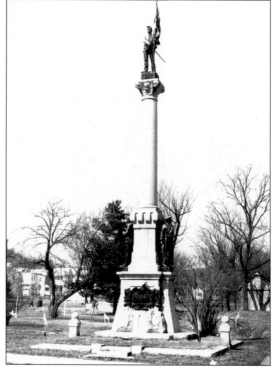

This classic monument was erected in Middleburg at the entrance of Glendale Cemetery in 1903. The memorial pays tribute to the county's Civil War veterans. However, controversy surrounded the design of the monument, and it was not dedicated until May 31, 2004. In an impressive ceremony, a wreath was laid by Snyder County veterans who were descendants of Snyder County Civil War veterans. About 50 Civil War veterans are buried in Glendale Cemetery.

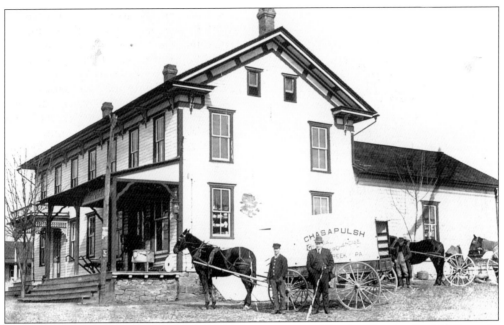

General stores were about the only stores in some parts of Snyder County. In Middlecreek, Spring Township, there was the store of Charles A. P. Ulsh. It is thought that Ulsh is the taller man standing by the horse and delivery wagon. Note the early washing machine and plow on the porch in this 1912 photograph.

The Patriotic Order Sons of America (P.O.S. of A.) was just one of many fraternal organizations that enjoyed popularity in Snyder County in the early part of the 1900s. This photograph, taken in 1917, is of the "new" P.O.S. of A. hall in Paxtonville. The building later became a movie theater. Noted on the back are two names: G. H. Oldt and Bill Gill. It is assumed that they are the young men directly in front of the telephone poles in the left portion of the picture.

Port Ann is another of those northern Snyder County villages many only hear of—if that. Regardless of size, in the 1950s it was able to support a fine baseball team—nothing to do with this picture. The real-photo postcard is postmarked October 18, 1910, and was sent by Josiah H. Bingaman, who tells a friend ("Mr. Dr. D. B. Bobb") of Dakota, Illinois, "This is our house in Port Ann."

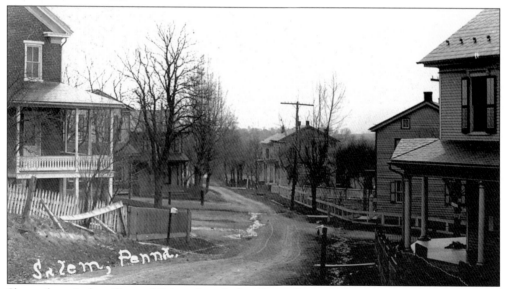

Shown here is the village of Salem, long before Pennsylvania governor Gifford Pinchot "took the farmer out of the mud" by paving as many roads as possible. Pinchot served the commonwealth from 1923 to 1927 and from 1931 to 1935. The village appears, c. 1912, to be little more than a wide spot in the road. Salem has retained is smallness and charm today. Most of the buildings shown still exist. Another Salem landmark—not shown—was Row's Church, built in 1813 and dedicated in 1816.

Inexplicably, the grave of governor Simon Snyder (for whom our county is named) was originally marked by only a mound of earth. Later, a headstone with no inscription was added. Eventually, the state legislature appropriated funds, and a fitting monument was built and dedicated at Sharon Lutheran Cemetery on Wednesday, May 25, 1885, by governor Robert E. Pattison. A life-size bust of the three-term governor and Selinsgrove resident tops the monument. The unveiling was performed by one of Snyder's great-granddaughters, M. Lillian Snyder.

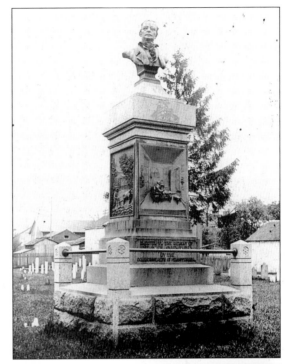

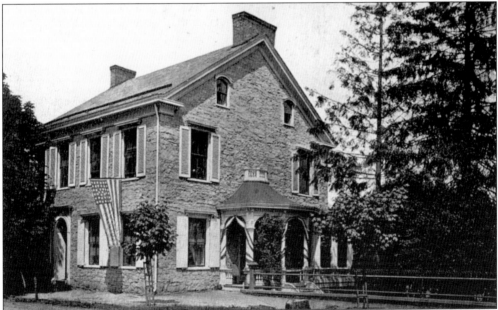

Ever since it was built in 1816 by Pennsylvania's only three-term governor, the Simon Snyder Mansion has been a Snyder County landmark. The site was at one time a stop on the Underground Railroad (the tunnel to Penns Creek is still there). After the property passed from the Snyder family, it served for many years, beginning in 1917, as the law office of Harry Coryell and, later, his son Pierce A. Coryell. It was also the family residence. For many years the mansion housed an upscale gift shop, and now a popular brew pub is located there. The property is also on the National Registry of Historic Places.

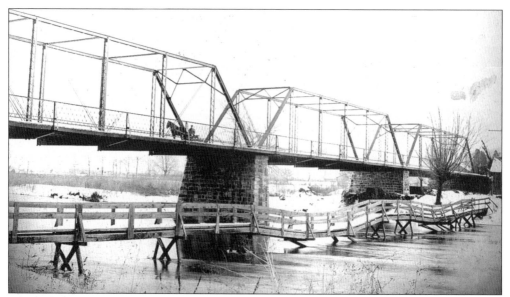

Almost from the time Selinsgrove was laid out by John Snyder, *c.* 1784, connecting the Isle of Que with the town has been vital. Construction of bridges over Penns Creek was done early and often, thanks to floods, fires, and other disasters. The span pictured here was opened in 1903, and this winterscape photograph was taken shortly after construction was completed. The footbridge in the foreground, which allowed pedestrian traffic during construction, is shown still more or less intact.

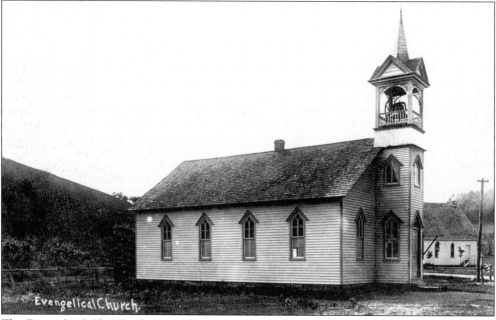

The Evangelical Church, shown in 1907, is located a mile or so *south* of Selinsgrove, close to Middle Creek. Perhaps that is why an early owner of the photograph blackened out the words Selinsgrove, Pa. The building to the right is also a church, though only the rear portion is visible. The twin churches exist today. The Evangelical Church is now Faith United Methodist Church, while the partially visible building is St. Paul's Lutheran Church. They are accessible via Middle Creek Road.

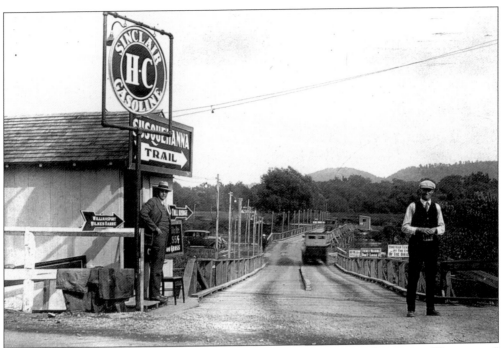

Seen here is a temporary bridge across Penns Creek, north of Selinsgrove. "Temporary" means just for August and September of 1928. The span existed while the relocation of a permanent Penns Creek bridge—now part of Routes 11 and 15—was undertaken. Enjoying the nice temporary financial windfall—55¢ a car—were a Mr. Goy and a Mr. Follmer, perhaps shown here. By the fall of 1928, the free permanent bridge facilitated ease of traffic flow on the Susquehanna Trail.

Before being renamed Shamokin Dam, the town was named Keensville, after early settler George Keen, as noted on the Keensville Hotel sign, which also notes the hotel was established in 1859. At the time of this photograph in 1908, C. H. Leffler was proprietor of the hotel that later became the Logan Hotel (of which Maude Logan was the proprietor) and still later The Old Trail Inn. The building was demolished in 1996.

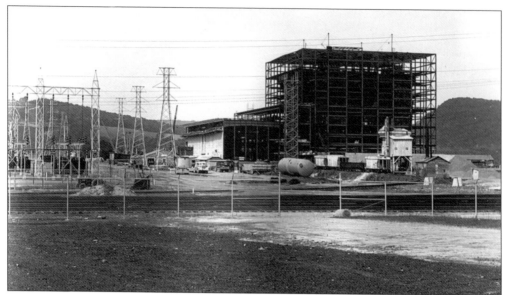

The advent of construction of the P P & L plant on August 28, 1946, changed the economic landscape of eastern Snyder County. Well-paying construction jobs and, later, just well-paying jobs, benefited many. The facility's first generator was synchronized on August 17, 1949, signaling completion of the world's largest anthracite-burning steam-generation plant. Thomas B. Richards was the first superintendent. His son Dave worked on the construction and provided much useful information about the facility.

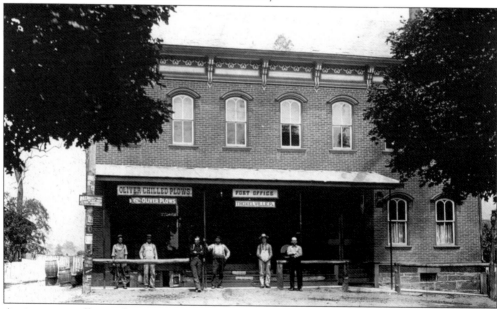

Again, a post office and store were combined, as seen in here *c.* 1915. This one, in Troxelville, has the post office housed in the Middleswarth & Mattern Store. Oliver Chilled Plows appear to be a store specialty. Other products advertised on a telephone pole are someone's spearmint gum and Dr. A. C. Daniel's Medicines & Home Treatments. The men strike poses reminiscent of Grant Wood's *American Gothic* painting. The store was later operated by Joe Herman, an antique dealer specializing in oak furniture.

Four

WE, THE PEOPLE

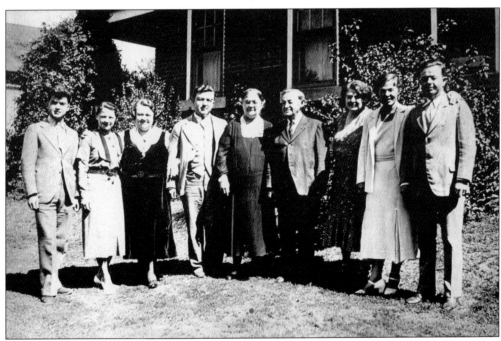

Prominent Selinsgrove residents Dr. Robert and Tillie Potteiger had quite a "litter," as grandchildren Chuck and Mimi Oberdorf termed them. There were seven children in all and each achieved greatly. Family members shown in this 1920 photograph are, from left to right, Jack, Helen "Sis," Mary, Albert, mother Tillie, father Robert Sr. (D.V.M.), Mildred, Ann, and Robert Jr., who like his father was a veterinarian. Other children were educators and artists. The Potteiger family residence on West Chestnut Street is now a popular bed-and-breakfast.

Jacob Sechler Coxey was born in a log house, now covered with aluminum siding, at 814 North Market Street in Selinsgrove on Easter Sunday, April 16, 1854. When he was 26 and working in the scrap iron business, Coxey moved to Massillon, Ohio. He became a champion of the working man and led Coxey's Army on Washington, D.C., in 1884 to call attention to unemployment. The army camped, many hundreds strong, in Washington for 35 days. Coxey, who ran for president twice, lived until 1951 and last visited Selinsgrove in 1925.

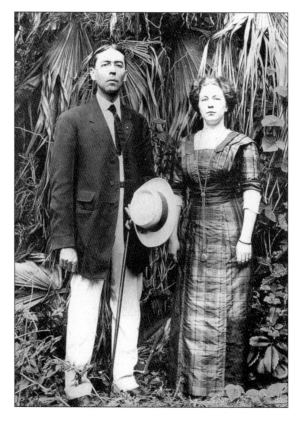

This young couple, married in 1910, is I. Newton Catherman and his wife, the former Edna Farley, both of Selinsgrove. They were honeymooning in Bermuda—probably not a common destination at the time—when this photograph was taken. Catherman was a successful salesman of drugstore fixtures. He also gained notoriety for having served as a guard on the funeral train of assassinated President William McKinley as it traveled from Buffalo to Washington, D.C., in September 1901.

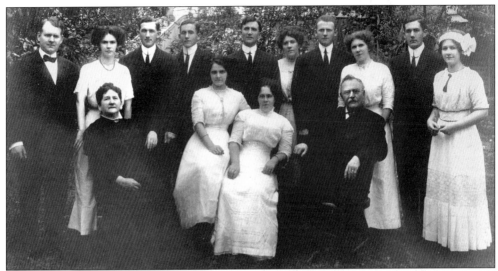

When Mary Jane "Polly" Jones Phillips joined her husband, Henry, who had already emigrated to Shenandoah, in 1883, she longed for her native Wales. She asked him to find "a small green town that has a college." Henry chose Selinsgrove. The clan is pictured here in 1911. From left to right are the following: (sitting) Polly, Aberdeen Phillips, Annie P. McLaughlin, and Henry; (standing) Harry Phillips, Mary Phillips, Garfield Phillips, Edward Phillips, William Phillips, Margaret P. Wingard, Wendall Phillips, Sarah P. Ulrich, Ben Phillips, and Esther P. Weeks.

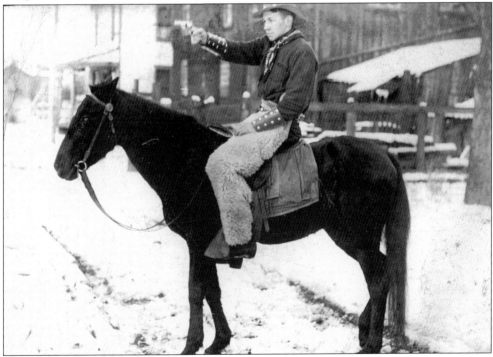

One of the most popular forms of entertainment during the early years of the 20th century was motion pictures. Even though the films were silent, their action scenes had a great influence on the audience. Here Hummels Wharf resident M. L. (Martin Levi) Bailey strikes a pose—astride his steed, with pistol aimed—that is reminiscent of the first Western action film star, William S. Hart.

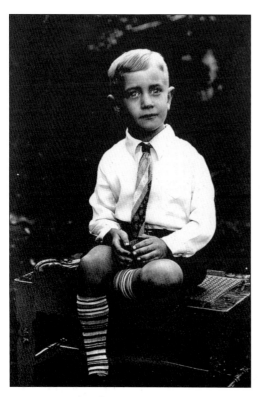

In addition to snapshots, Snyder County families often had more-formal photographs taken. This handsome 1930 photograph of Don Bogar, age 6, is a perfect example of that. Don grew up to be a fine young man, served his country in World War II, and became a true friend to all with whom he came in contact. After retiring from IBM, he and his wife, Mary (née Herman), spent many happy years on a farm in the Beaver Springs area.

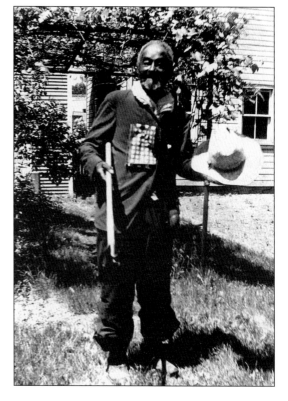

Pete Washington came to Middleburg in the 1930s and was quickly adopted by the community. He had no formal home, but was welcome almost everywhere. Mrs. Mary Agnes Rice "provided him with breakfast and supper as long as he was around." Pete was a fixture, sitting on a bench by the courthouse, and every morning—while looking skyward—singing the hymn "Somewhere a Light is Shining." When he died on October 20, 1937, local businessmen gave him "one of Middleburg's biggest funerals."

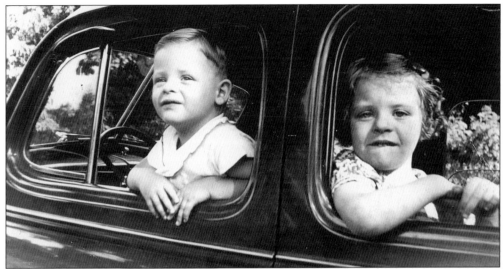

Family cars were often props for family photographs in the 1930s and 1940s, when automobiles were not quite as common as they are today. In 1940, five-year-old Carol Campbell (right) seems less than thrilled at being chauffeured by her three-year-old brother. The vehicle is a 1939 Chevrolet sedan, whose color is best described as resembling Campbell's tomato soup. The car was victimized by gas and tire rationing early in World War II, and was sold—to the later chagrin of all concerned.

This timeless photograph of Amish youngsters, taken on North Market Street in Selinsgrove, could have been snapped yesterday. Actually, Charlie Fasold took the charming photograph in the summer of 1940. Other photographers later found the Snyder County "Plain People" a fascinating subject. Mostly, though, the Amish and Mennonites living among us in Snyder County are somewhat camera-shy.

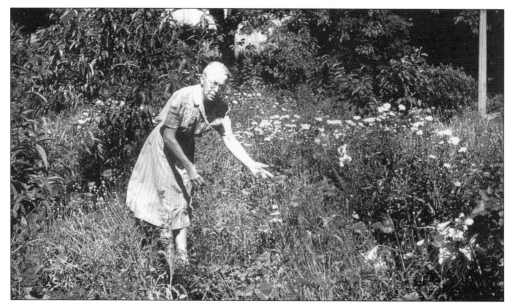

Residents of Snyder County have always had a penchant for growing things, be it food for the table or more aesthetic plants, such as flowers. Selinsgrove resident Mame Romig, long a fixture about town with her outgoing personality and jauntily worn hats, was one who had a green thumb. Many of her neighbors were recipients of her colorful homegrown flowers. Pictured in 1953 in her Pine Street garden, Mame tends poppies and daisies.

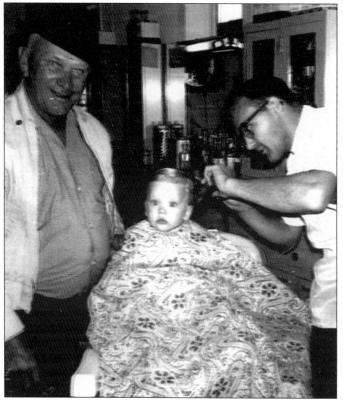

As one grows up, life is a series of firsts. Certainly one of the most memorable moments is the first haircut—for the family, if not the recipient. Locks of a youngster's hair are often saved for years. Grandpa Paul "Barney" Blazer (left) proudly beams as Billy, son of Paul's son Reynolds "Rennie" Blazer, is expertly trimmed by Leon Earl Fetterolf, a former Beaver Springs resident who manned a chair in Shaffer's Selinsgrove barber shop.

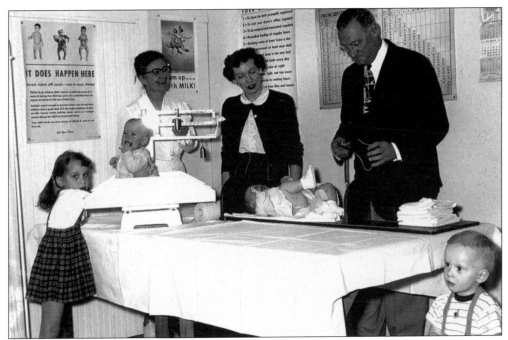

Selinsgrove's answer to the well-baby clinic was photographed in December 1951. Five-year-old Becky Herman, in plaid, tries to pacify six-month-old sister Brenda, on the scale, while Dr. Russel Johnston, nurse Lucinda Bingaman (back left), and Joyce Rogers check another tyke—Mrs. Rogers's daughter Allison. The other little guy to the right is Dean Hettinger. The sponsor of the health screening at the Selinsgrove Community Center was the Junior Women's Club.

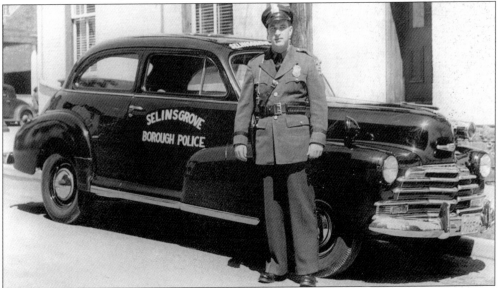

Officer Charlie Gemberling, half of the Selinsgrove Police force for many years in the 1940s and 1950s (Chief Ezra Kemberling was the other half), stands beside the town's first cruiser—a fully equipped 1947 Chevrolet. The cost of the Chevy Tudor was $1,042. The photograph is dated April 26, 1947. Officer Gemberling's son, Charles "Bud" Gemberling, followed in his father's footsteps by serving with the Pennsylvania State Police.

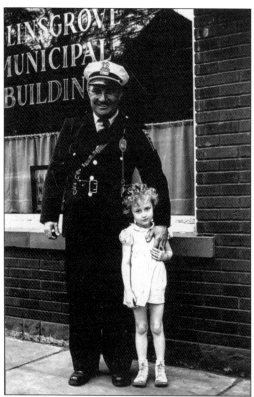

The dark-eyed little beauty pictured here—shielded from any possible harm by the sturdy arm of Selinsgrove Police Chief Ezra "Ez" Kemberling—after many years has been identified as Judy Stutz, the daughter of Joe and "Tizzie" Stutz. Her father was once a member of the Selinsgrove police force, prior to when this 1946 photograph was taken in front of the Selinsgrove Municipal Building (now the Miller Agency). Judy's Mona Lisa–like smile and look of total assuredness make this a photograph not easily forgotten.

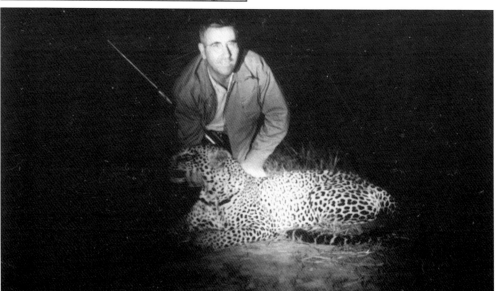

Simon Rhoads of Selinsgrove was "the Great White Hunter" on at least two continents, North America and Africa. Shown is the true outdoorsman with a leopard he bagged in Africa during one of his first safaris in the early 1950s. Rhoads took the big cat at dusk, and a Jeep's headlights provide the illumination for this unique snapshot. Many Snyder County residents' first exposure to big-game hunting and exotic places was through Rhoads's films, which he generously shared with many community organizations.

Rolling Green Park was known as the People's Playground. One of the main venues for playful activities was Crystal Pool, a mecca for summer bathing and frolic. Selinsgrove residents Bob McFall (left) and Tony Ritter mug for the camera. The female bathers seem to be oblivious to the men's antics. Like many of their fellow residents, McFall and Ritter soon left to serve their country in World War II.

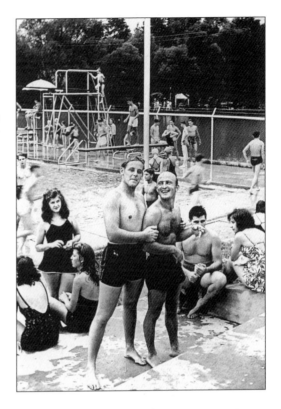

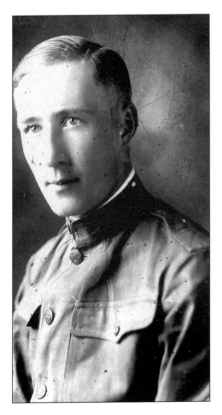

Sgt. Brewster Cameron Schoch was one of those gallant Americans who, in time of war, made the supreme sacrifice. As a member of the Headquarters Troop of Pennsylvania's 28th Division, he was shipped to France in the spring of 1918. Schoch became Snyder County's first World War I casualty when he was killed in action on July 29. Sergeant Schoch is buried in the Aisne-Marne American Cemetery at Belleau, France. A memorial service was held in Selinsgrove on Sunday, September 1, 1918.

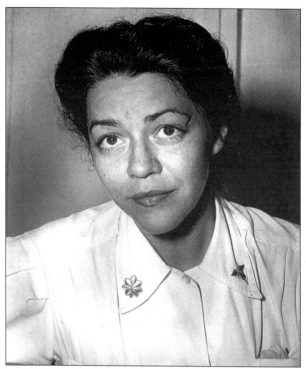

Twins Inez (shown) and Irma Boyer of Paxtonville were unusual women of the 1920s. Both pursued higher education. Inez, a nurse, graduated from Johns Hopkins, and Irma, a vocalist, studied at the Westminster Choir College. Inez became an army nurse before Pearl Harbor and eventually was director of army nurses in the Pacific, where she came in contact with Adm. William "Bull" Halsey and Eleanor Roosevelt, among others. Inez later married Gen. Earl Maxwell, her former World War II commander.

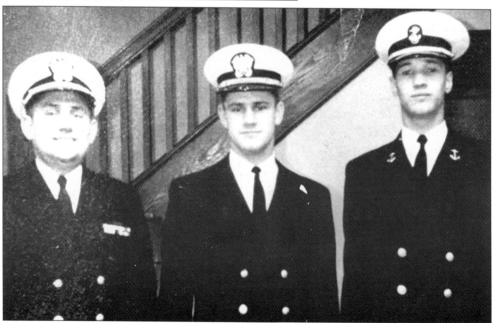

Upholding a family tradition of serving their country, the three Keiser brothers of Selinsgrove saw service in the U.S. Navy. Shown in a 1960s photograph are, from left to right, Lt. Bob Keiser, Lt. JG. Jim Keiser, and Midshipman Ron Keiser. Bob served on a landing ship tank in the South Pacific during World War II, and was in the navy from 1941 to 1980. Jim served in the Mediterranean, and was in the navy from 1958 to 1980. And Ron served off the coast of Vietnam, and was in the navy from 1966 to 1986.

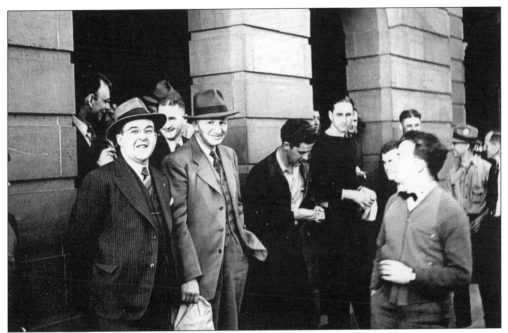

Answering the call has long been a Snyder County tradition. After the United States entered World War II following the December 7, 1941 attack on Pearl Harbor, this group reported for duty at the Middleburg courthouse on Monday, April 27, 1942. Pictured from left to right are Laird S. Gemberling, Marshall Kaufman, Si Knouse, Delbert Hummel, and Claude Troutman. The men likely reported to the Indiantown Gap Military Reservation for their draft physicals. The Gap and New Cumberland were where county inductees reported during the war.

One of the most poignant stories of World War II is that of Sgt. Jack E. Wagner, the 19-year-old son of Jake and Edna Wagner of Selinsgrove. Sergeant Wagner was a tail gunner on a B-24 Liberator. After another B-24 cut off the tail of his plane, he plunged 20,000 feet to his death near Marstal, Denmark. Marstal residents Nels and Natalia Mortensen cared for Wagner's grave for decades. When asked why, they said simply, "He died for us." Sergeant Wagner was married to Dorothy Snyder. They had a daughter whom he never had the opportunity to meet.

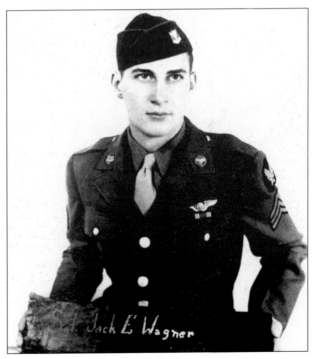

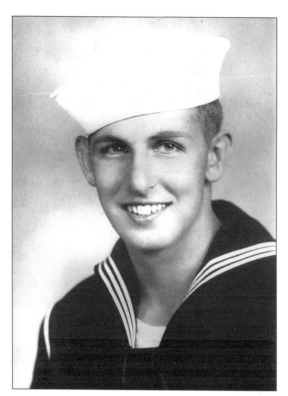

Bob Burns of Selinsgrove became Seaman Recruit Burns, Robert S., on Monday, March 22, 1943, and began boot camp at Sampson Naval Base in New York. An aviation radio mechanic, he served with two utility squadrons in Memphis and Philadelphia, before being honorably discharged in December 1945. Schooled in radio and radar, he was able to fly in one plane and remotely control several others. Bob's brother Jim served in the army in France, while another brother, Jay, was in the navy.

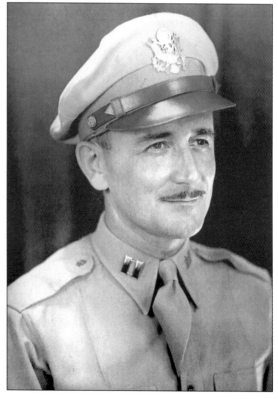

Harvey P. Murray Sr. was a true rarity—a politician without political enemies. He began his career as an assistant district engineer for the state highway department, and became district superintendent in 1939. At the advanced age of 38, he enlisted in the Army Corps of Engineers and served in the Canal Zone before being honorably discharged as a captain. He was a Selinsgrove burgess, a state representative, and finally, Snyder County register and recorder from 1961 until retiring in 1977.

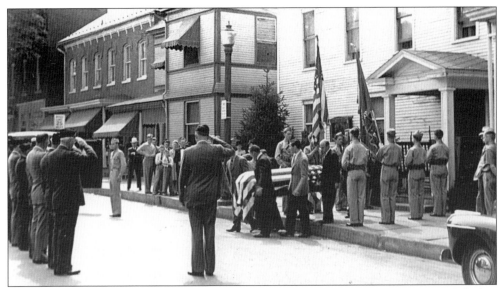

Snyder County's first World War II casualty was George Fry of Selinsgrove, who was killed in a glider accident during training in Colorado. His body was returned home in August 1942. Full military honors were accorded the fallen aviator. Fry's boyhood friends sadly served as his pallbearers, and they included Charlie Pinand, Bob McFall, and Tony Ritter, who would later serve in the war. Fry's burial at Union Cemetery in Selinsgrove was from the Willard Maginnis Funeral Home on North Market Street.

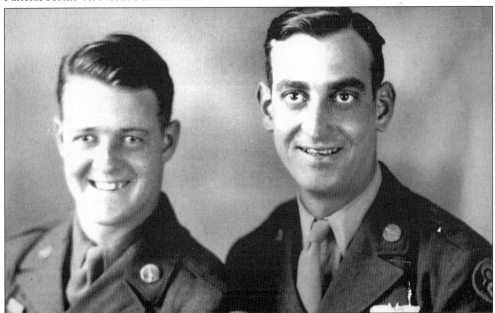

Edgar "Eddy" (left) and Paul Neff were two of five brothers to serve during World War II. The quintet represented several branches of the service, and served in both Europe and the Pacific. Born in Clearfield County, the Neffs came to Snyder County when their father, a Lutheran minister, answered calls to churches in Richfield and Freeburg. The brothers' broad smiles here can be partially attributed to the fact that they were in England at the time of this photograph, on July 13, 1945, well after V-E Day marked the war's end in Europe.

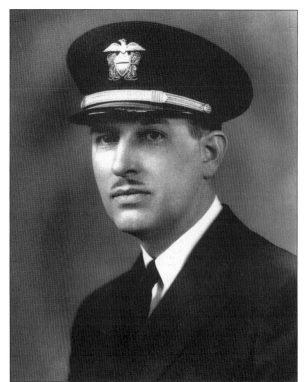

Horace Vought had already established himself as a promising Middleburg attorney by the middle of World War II. He was starting his second term as Snyder County district attorney when he resigned and joined the navy in April 1944. As a lieutenant and legal officer in the Judge Advocate General's Corps, Vought was assigned to the 12th Naval District in Farragut, Idaho. After the war, he returned to his private practice, until his retirement in 1979.

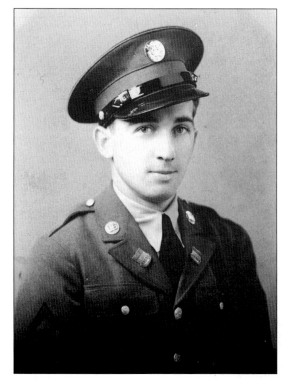

Guy W. Troup was assigned to U.S. Army Company C, 12th Engineering Battalion, 8th Infantry Division. Within a year of arriving in Europe, he took part in the campaign for Brest, and fought across France, Luxembourg, and into Germany, where he was wounded on February 23, 1945. During his service, Troup kept close contact with his friends and family. In 2002 his son Mark published those letters in *My Dear Son Guy: World War II Letters to and from Paxtonville, PA.*

Robert Graybill of Paxtonville was the first Snyder County resident to be selected into service under the Selective Service Act of 1940. He volunteered for duty after his draft number was taken high up on the list in the October 29, 1940 lottery. Maurice Heiser of Middleburg actually held the first draft number, but Graybill's volunteering filled the county's one-man quota in the first call. Graybill served as a sergeant in the First Veterinary Company in the China-Burma Theater for two and a half years.

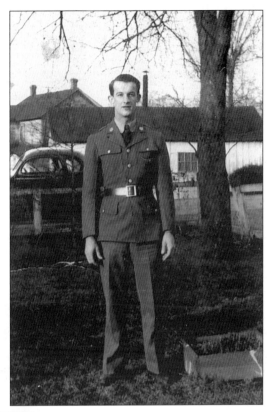

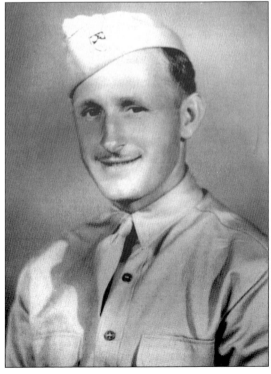

Maurice Heiser of Middleburg had the distinction of holding the first draft number in the Selective Service Act of 1940's draft lottery on October 29, 1940. But because Robert Graybill (previous photograph) volunteered, Heiser was not called to duty until January 14, 1941. Heiser was shipped overseas and served with the Second Infantry Division. He made the supreme sacrifice on Sunday, July 16, 1944, when he was killed in action near St. Lo, France.

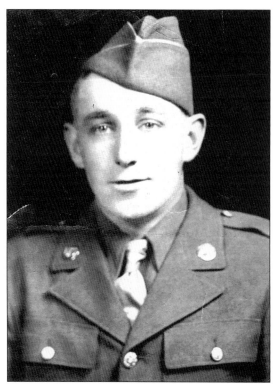

Eugene Herrold of Port Trevorton typifies what author Tom Brokaw called "the Greatest Generation." A member of the First Infantry Division (a.k.a. "The Big Red One"), Herrold was wounded three different times—in Sicily, at Normandy, and in Germany. He was part of the bloody Omaha Beach D-Day landing on Tuesday, June 6, 1944. Herrold was decorated by the United States and France. His medals include three Purple Hearts, three Presidential Unit Citations, and the hard-earned Combat Infantryman's Badge.

Wilfred "Willie" Sheetz of Selinsgrove interrupted his freshman year at Susquehanna University to enter service in February 1943. Assigned to the 110th Infantry of Pennsylvania's own 28th Division, Sheetz was wounded and taken prisoner by German troops as he fought in the Ardennes Forest at the Battle of the Bulge on December 18, 1944. As a prisoner of war, he lost 60 pounds while he was held in Stalag IX B. Before being discharged from service, Sheetz spent considerable time in Valley Forge Military Hospital.

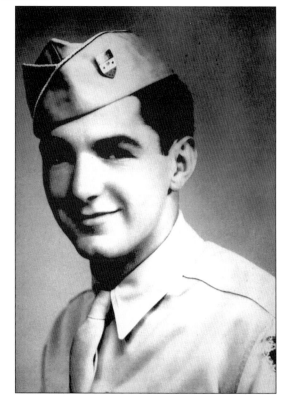

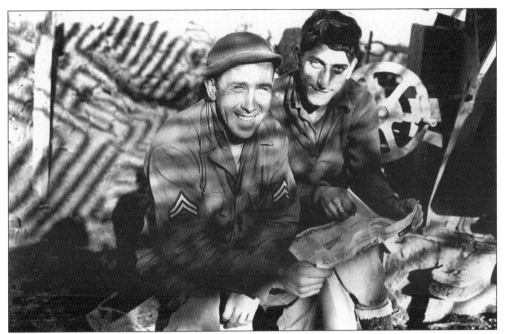

In this U.S. Army Signal Corps photograph, Pvt. Frank DeDay of Hummels Wharf (right) is shown with a Philadelphia buddy, Cpl. Walter Forys, as they read a copy of the GI newspaper *Stars and Stripes*. They are with the Sixth Army Group "somewhere in France." DeDay served as an artillery cannoneer, earning two Battle Stars. The shadows crisscrossing the photograph are caused by camouflage nets over their artillery piece. A note on the photograph states "Passed for publication by Field Press Censor."

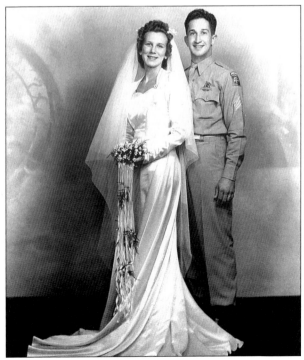

Shortly after V-J Day and the end of World War II in the Pacific, Sgt. Marshall "Bud" Herman and Ruth Bailey, of Selinsgrove and Hummels Wharf, respectively, were married in New York City on Friday, August 17, 1945. Like many couples, they had postponed their wedding day for the duration of the war. Bud was a member of the highly decorated 82nd Airborne—note the jump boots— and took part in the Sicily and Italian campaigns. He sustained injuries during a jump that required him to spend considerable time in an English hospital.

This is more than a wedding photograph of a young couple from the 1940s. It is a World War II GI and the first Pennsylvania war-bride. Ardell Landis of Mount Pleasant Mills met Edith Quabeck in Berlin during German occupation in September 1945. They dated, and when Ardell returned home they made plans to marry. Helped by Horace Vought [see page 62], Edith was able to cut through the red tape and be reunited with Ardell. They were married at the home of Ardell's parents on the evening of Saturday, December 28, 1946.

It is hard to imagine a wartime mother suffering more anguish than Mrs. Clara Smith of Middleburg, whose sons Howard and Bob were wounded in 1950 during the Korean War. Howard (in photograph) enlisted in 1948, and was in Korea when the North Koreans crossed the 38th Parallel in June. He was shot in the chest and arm in August near Pusan. Bob was wounded near the Chosin Reservoir, during the frigid retreat. He suffered severe frostbite and lost parts of both arms and legs, and became the Korean War's first quadruple amputee.

Five

THE THREE R'S
AND BEYOND

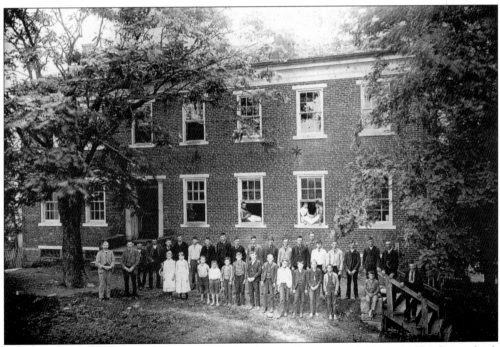

A note on this photograph says, "Freeburg Academy—Summer of 1854 or 1855." Some think the picture could be from a later date, but regardless, the academy was opened on Monday, October 10, 1853, with Professor Jacob S. Whitman as principal. An early morning fire on Saturday, October 13, 1855, razed the original building, but it was almost immediately rebuilt. For the 1870–1871 school year, tuition costs were $1 per quarter. The school closed c. 1910.

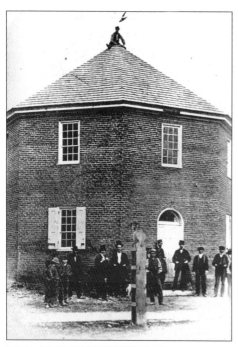

This eight-sided building was constructed on South Market Street in Selinsgrove in 1816, and was known as the Pepperbox School because of its shape. It was the first public school in the county. In addition to being a place of education, the building also served as a Sunday school, and during the Civil War (the time of this photograph) it was an armory. Unanswered questions are: How did Matt Gardner get to the top of the roof, and why did he do it?

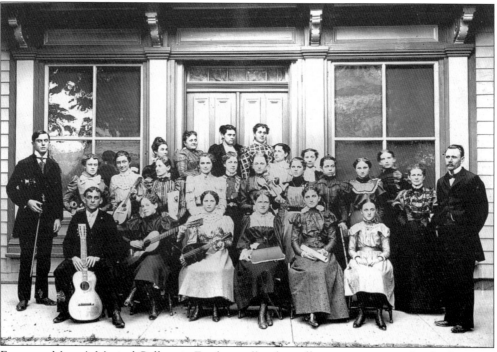

For years, Moyer's Musical College in Freeburg offered excellent instruction under the direction of Frederick C. Moyer, and later by his son William. Another son, Henry B., is standing at the right. His sister Anna J. is beside him. The spring-term class of 1898 is shown here. On the back of the photograph, names are noted, but no order is given. They are: "Misses Norton, McLeod, Goring, Geis, and Card; Kistler, Burke, Ada Kelly, Shirley, Bosley, Bowersox, Fritz, Hess, Reinsmith and Houser; Mr. Kell, Walter, Oswald, Eby, Meiser, Miller, and Fritz."

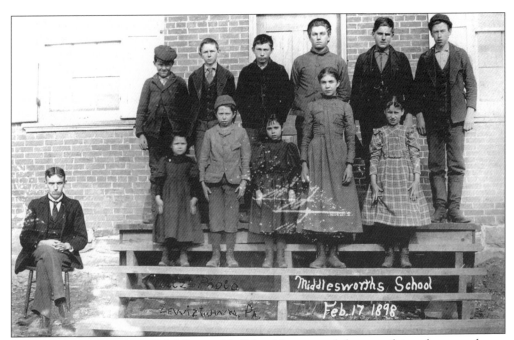

Photographs such as this of Middlesworth's School have stood the test of time for more than a century. The photograph, by Fultz of Lewistown, was taken on Thursday, February 17, 1898. Judging from the stern expression on the unidentified teacher's face (far left), it is fair to assume that discipline was not a problem at Middlesworth's, which was located in northern Snyder County, along the road between Port Ann and Penns Creek.

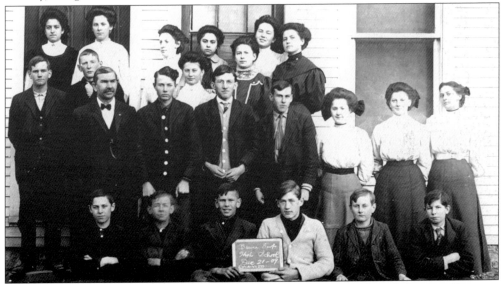

During the 1909–1910 term, Beaver Township High School had a relatively low enrollment—only 22 students and one teacher are shown. The number of male students is encouraging, since young men often passed up schooling to help on family farms. The slate, held in front, identifies the school and date as December 21, 1909. Below are the initials J.W.A. and W.D.W. They may be the initials of the slate-holders. The school was a forerunner to Beaver Vocational High School in Beaver Springs.

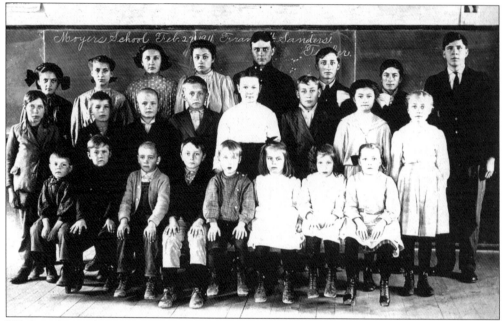

While we know the teacher at Moyer's School is Frank Sanders, we are left in the dark as to the identity of the students, who appear to be in grades one through eight. The Spring Township school, "below Troxelville," was founded in 1868. Ironically, we know from a note on the back of the photograph that "Margaret Mitchell, 6 years old, absent" is not in the picture.

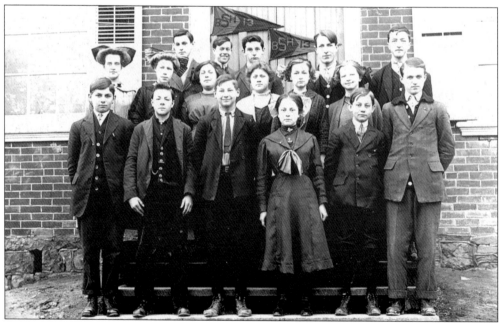

To attend school at Beaver Springs High School at the time these students did in 1913 was not something taken for granted. At home there were crops to plant, tend to, and harvest, as well as younger siblings to care for, household chores, and other duties to perform. No wonder most of the students beam with pride as they donned their Sunday best for this group picture.

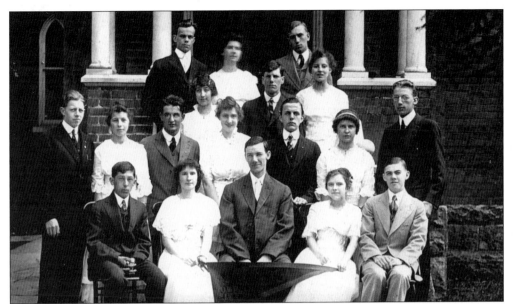

Graduating classes now are almost always made up of more than 100 students. The 1915 Middleburg High School seniors are far fewer, but no less proud than graduates of today. Identified by name, but not order, are the following grads: Dorothy Charles, Marian Charles, Florence Emory, Ruth Bartholomew, Edna Graybill, Dean Graybill, Evan Hassinger, George Gemberling, William Keister, Stanley Millhouse, Mabel Smith, Erma Snyder, Russell Stetler, Harry Snyder, Clara Hill, Paul Winey, and Dewey Winey.

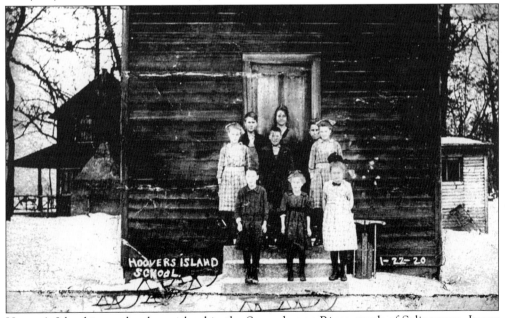

Hoover's Island is a rather large island in the Susquehanna River, south of Selinsgrove. It was large enough to farm and support at least one family and several summer cottages. Shown on Thursday, January 22, 1920, are the eight students of the Hoover's Island School in front of their stark school building. A note states, "All from one family." Some students apparently rode their sleds to school.

These 35 students made up a rather large third-grade class at Selinsgrove's Pine Street School when they lined up first thing Monday morning, September 24, 1923. Noted on the back is the name of the teacher—"Miss Jennie Miller" (not shown). Two students are identifiable, Charlie Fasold and Bob Shadle, the last two boys in the back row. Both went on to distinguish themselves—first as athletes and then as longtime, respected administrators in the Selinsgrove School District.

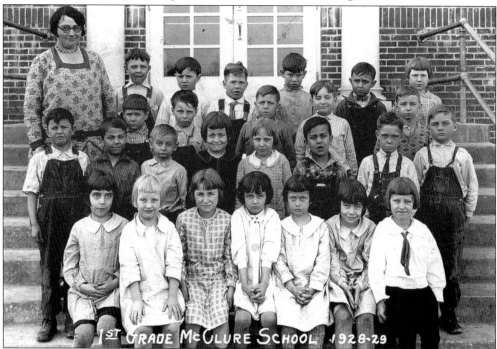

Though no specific information is given, the next two photographs of western Snyder County schools most certainly were taken by the same roving photographer. The captions "1st Grade McClure School 1928–29" and "Penns Creek Grammar Band 1930–31" appear identical. Expressions on the pupils' faces indicate varying degrees of enthusiasm for scholastic endeavors.

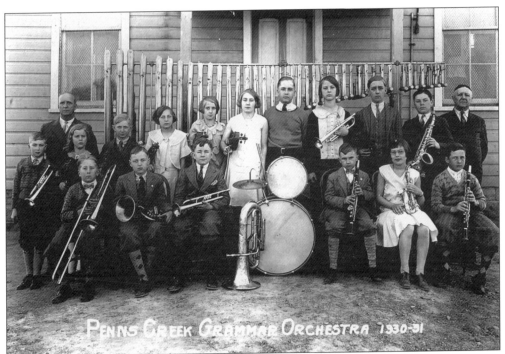

PENNS CREEK GRAMMAR ORCHESTRA 1930-31

A well-rounded education involves more than just what is learned in the classroom. Perhaps the out-of-class activity that has the most lasting effect is music. The Penns Creek Grammar [School] Orchestra from the 1930–1931 school year was under the direction of two band leaders. Looking closely, one can see the pride these youngsters have in their instruments.

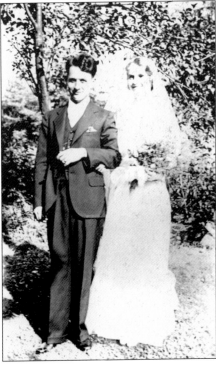

When W. Michael Weader and Kathryn Seal Fleming were married on Sunday, June 10, 1934, they were already having a profound effect on the lives of youngsters in Snyder County's West End. Both were teachers and would remain lifelong educators. Wife "Kippy" returned to teaching after raising Bill, Joe, and Lois. Mike progressed from teaching to school administration, and eventually became superintendent of the Selinsgrove School District, where he met consolidation and other challenges successfully.

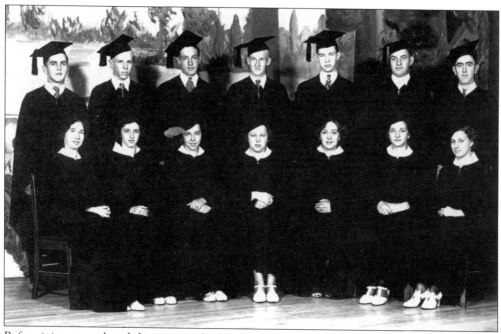

Before jointures reduced the county's high schools to three, nearly every Snyder County town of any size had its own. Freeburg was no exception. Posing for a formal class portrait are the 1937 Freeburg High School graduates. From left to right are the following: (first row) Anna Snyder, Miriam Bottiger, Irene Lauver, Marie Mengel, Norma Meiser, Verna Moyer, and Viola Harman; (second row) Herbert Benner, Darwin Lesher, John Hoffman, Robert Glass, Wayne Moyer, Ernest Kratzer, and John Boyer.

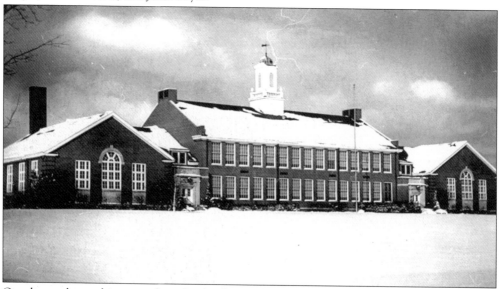

One lesson learned in compiling this book was that snow can only enhance the beauty of a photograph. Selinsgrove High School, thought by many to typify educational elegance, benefits from this theory in a winterscape by Charlie Fasold, long an administrator in the school district. Funded by a New Deal program and a $50,000 bond issue, the school was dedicated on Friday, May 21, 1937. The photograph was taken not too many years later.

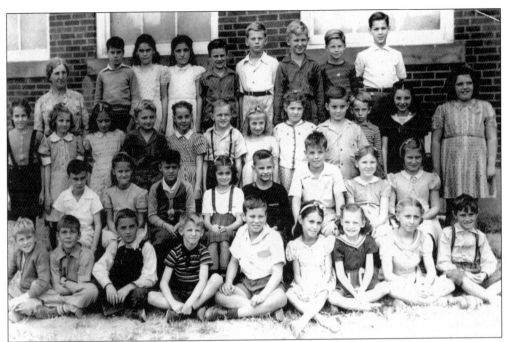

Miss Ethel Bolig's 1941 Pine Street School (Selinsgrove) fourth-grade class is pictured here. From left to right are the following: (first row) G. Sheetz, R. Loss, E. Hollenbach, L. Krebs, L. Foreman, J. Gilbert, M. Forster, unidentified, and E. Naugle; (second row) I. Lessman, J. Stuckey, G. Poe, M. Groce, D. Schoch, J. Keller, J. Sheaffer, and G. Gemberling; (third row) N. Owens, A. Schrader, B. Hetherington, L. Romig, J. Spotts, R. Rowe, V. Fritz, M. Hare, J. Steffen, K. Thomas, M. Kemberling, and B. Siegfried; (fourth row) Miss Bolig, W. Gaglione, J. Walters, B. Hare, H. Kline, R. Kinney, W. Bone, R. Ulrich, and G. Poe.

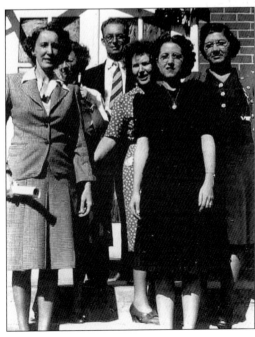

The backbone of any education system is the faculty. Shown here is the 1947 faculty of the Beaver Springs Grammar School. From left to right are Ethel Felker, Anna Mae Patton, Benjamin Gill, Virginia Shambach, Geraldine Hummel, and Alice Herman. Student-photographer Leon Earl Fetterolf snapped this photograph.

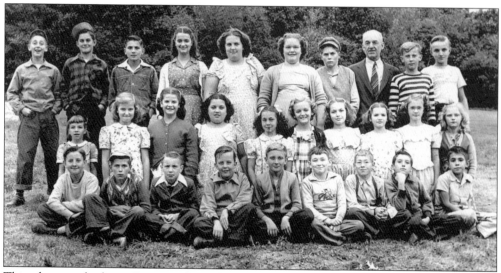

This photograph shows Fremont Grammar School pupils during the 1948–1949 term. The students are, from left to right, as follows: (first row) Don Roush, Earl Maneval, Paul Heintzelman, Dave Garman, Nevin Stuck, Ivan Pecht, Ray Dock, Darwin Apple, and Lester Stuck; (second row) Marion Dock, Edna Moyer, Charlotte Mengel, Patsy Master, Sylvia Fogel, Sara Ann Master, Letha Wendt, Ruth Ann Sierer, Nancy Sierer, and Alma Maneval; (third row) Junior Hood, Clarence Shadle, Reno Benner, Shirley Apple, Bernice Master, Shelva Ebright, Russell Maneval, teacher Charles Bottiger, Harold Kepler, and Henry Wendt.

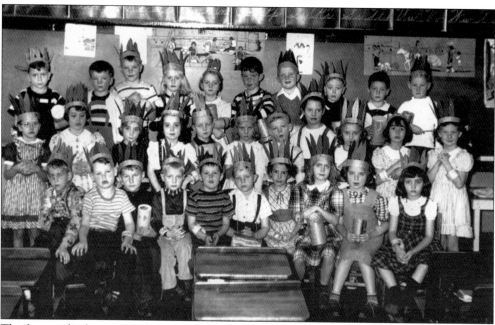

The first-grade class of 1949 at Selinsgrove's Pine Street School dons Indian headdresses. Pupils contacted could not provide identification for all, but the known braves and squaws are, from left to right, as follows: (first row) Jon Zagars, Terry Klock, Barry Lewis, Dale Miller, Jerry Schuck, Jim Swineford, and Nancy Wolfe; (second row) Wanda Steffen (third from left) and Sally Schnure (fourth from right); (third row) Barry Kahn (sixth from left).

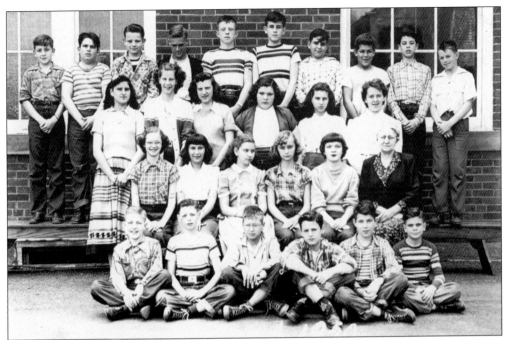

Picture Day was May 4, 1950, for Miss Ethel Bolig's seventh-grade class at Pine Street. From left to right are the following: (first row) Denny Bowen, Jim Campbell, Karl Fahnestock, Gene Christine, Jack Krohn, and Gary Aucker; (second row) Diane Miller, Faye Lewis, Roberta Frost, Diana Fisher, Claudette Bedeaux, and Miss Bolig; (third row) Jean Nace, Loretta Good, June Moyer, Lorraine Kelly, Carolyn Bingaman, and Sandra Heiser; (fourth row) Bob Anderson, Bob Wagner, Bob Benner, Bob Shaffer, Bruce Diebert, Don Nichols, Mitch Herring, Ken Krohn, John Gaglione, and Ron Forster.

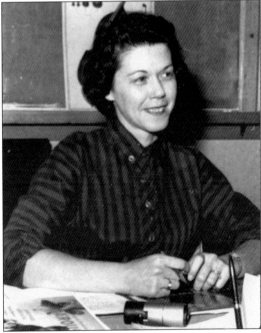

Every student usually finishes his or her education with a favorite teacher—one whose influence is felt beyond their school years. For many in Selinsgrove, June Hendricks Hoke was such a teacher. She was much more than a music teacher. She was a mentor, a role model, a confidant, and an inspiration. No doubt many students who pursued a music career were started in that direction by Mrs. Hoke.

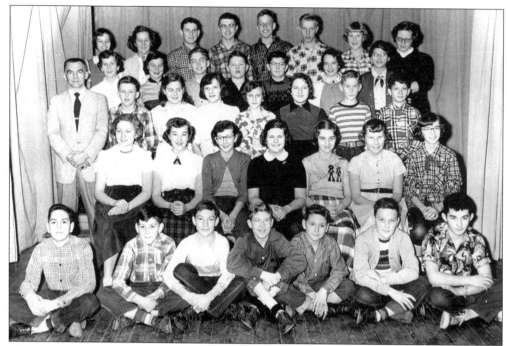

Shown is Chet Rowe's Selinsgrove seventh-grade homeroom class in 1955. Students are, from left to right, as follows: (first row) R. Reggia, J. Stuck, R. Walter, L. White, J. Youngman, L. Shaffer, and G. Sheaffer; (second row) W. Varner, L. Witmer, M. Martin, P. Mitchell, K. Smith, A. Lewis, and N. Jarrett; (third row) Mr. Rowe, G. Snyder, E. Inch, C. Kerstetter, S. Roush, D. Reeder, D. Swank, and F. Gearhart; (fourth row) B. Lessman, S. Kline, T. Crummey, D. Snyder, J. Tompkins, P. Ulrich, and M. Valunas; (fifth row) A. Sholley, M. Hoke, J. Riegel, A. Shaffer, R. Reichenbach, W. Tharp, C. Hoover, and D. Wagner.

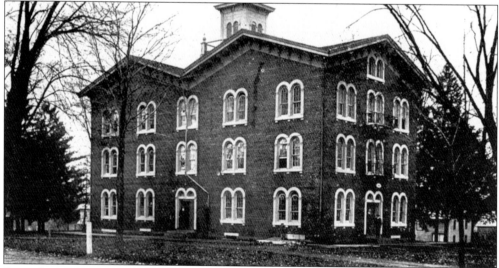

Susquehanna University was founded in 1858 as the Missionary Institute. Selinsgrove residents subscribed $25,000 for the construction of Selinsgrove Hall—the first, and for a time, the only, building on campus. It housed everything, including the president's residence, dormitories, classrooms, a chapel, a dining hall, and offices.

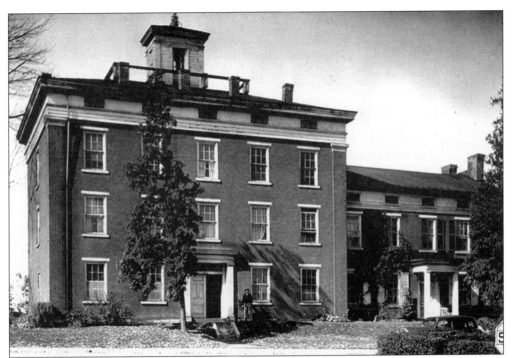

This is a 1936 photograph of the Noetling Building, which was originally the Susquehanna Female College, located at Market and Snyder Streets in Selinsgrove. The school accepted its first students in 1858. When the female college merged with the Missionary Institute in 1895, the name Susquehanna University was adopted, and it became one of the first co-ed schools in the nation.

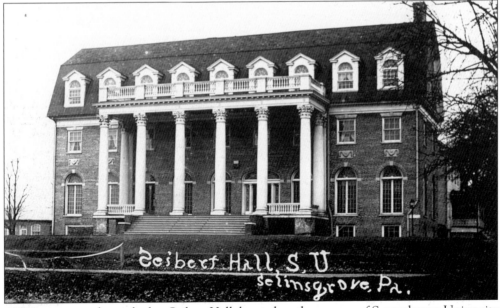

A strong case can be made that Seibert Hall, located on the campus of Susquehanna University in Selinsgrove, is the most elegant building in the county. Eight stately Corinthian columns are its architectural signature. This photograph is from 1921. The building was placed on the National Registry of Historical Places, as was Selinsgrove Hall, in 1979.

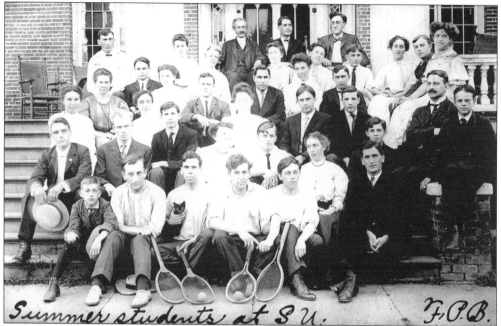

College summer school in the early 1900s was either popular or unpopular, depending on your viewpoint. Teachers with normal-school educations needed to take additional credits toward a baccalaureate degree. Younger students may have needed to boost their grades. Regardless of motivation, it would appear that these summer school students at Susquehanna University in 1906 had time for studies, as well as a few sets of tennis.

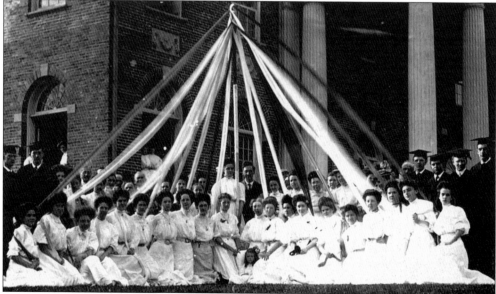

The celebration has lost some of its significance over the years, but for a long time the observance of May Day on college campuses was a big event. The winding of the Maypole was a rite of spring dating back to pagan times. Pictured is May Day at Susquehanna University in 1908. Note the young beauty in the center of the front row almost obscured by the adults in the May court.

Six

SPORTS, GAMES, AND RECREATION

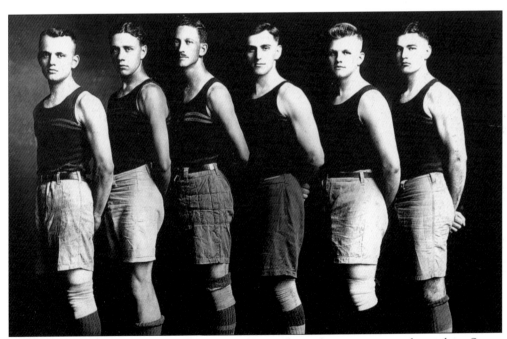

Snyder County residents have always felt the need to relax, recreate, and socialize. Sports activities satisfy these needs. Compared to baseball, basketball was relatively new when the Keystone Club of Selinsgrove formed this team in 1924. The players are, from left to right, Al Seiler, James "Pete" Youngman, Harold Follmer, Everett "Cuffy" Bolig, Bruce Wagenseller, and Ken Moyer. The team took on all comers, and is said to have played the Original New York Celtics—a top professional team of the day.

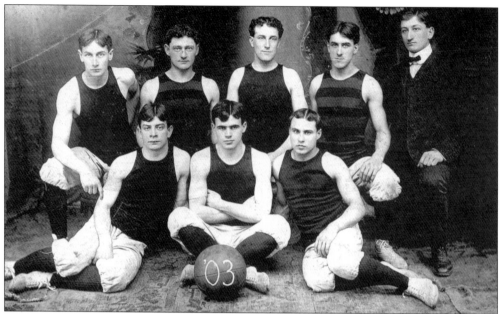

Basketball was invented by Dr. James Naismith in 1891. The game spread quickly. Shown is the 1903 Susquehanna University team. Crusaders players are identified by name, but no order is given. The starting lineup was: coach and captain Lou Roberts, Selinsgrove native Foster Benfer, W. Sholley, E. P. Sones, and W. R. Camerer. Subs are listed as P. H. Pearson and A. S. Hoch, and the manager is Clay Whitmoyer. Benfer is at the extreme right in the first row; Whitmoyer is in the back row in "civvies."

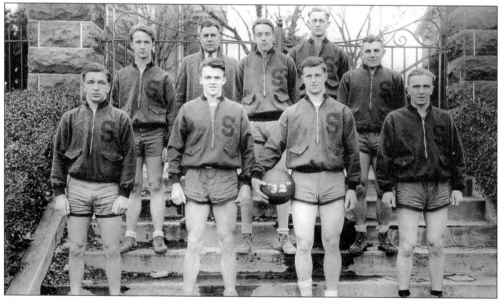

The gate at Susquehanna was a popular site for team photographs. On Tuesday, March 15, 1932, the Selinsgrove High Seals stood on the steps there. The squad, like all SHS sports teams, was coached by Harold L. "Pete" Bolig. Pictured are, from left to right, the following: (front row) Marvin Wentzel, Max Kahler, Bob Shadle, and Jack Kahler; (second row) Rudy Gelnett, Charlie Fasold, and Roy "Himmie" Bolig; (third row) Coach Bolig and Dick Forster.

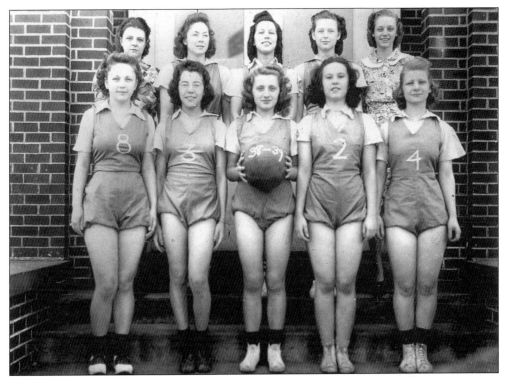

Coached by Kathryn Fasold, the 1938–1939 Middleburg High School girls basketball team won the Snyder-Union League championship by defeating defending champions Mifflinburg on the road, 21-14. Middleburg players are, from left to right, as follows: (first row) Helen Hornberger, Marian Steese, captain Helen Steininger, Betty Pearson, and Betty "Blondy" Erb; (second row) Coach Fasold, Louise Stahl, Helen Reigel, Marian Roush, and manager Florence Soles. The team's home court, called the "coal bin," had a cement floor.

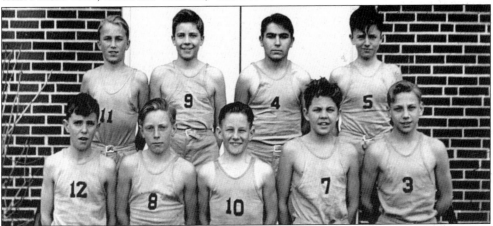

Youth basketball usually took the form of pickup games in the early years. Sometimes the court was a peach basket nailed to a garage, a barn, or a convenient telephone pole. As early as 1941–1942, Selinsgrove had an eighth-grade team. Team members are, from left to right, as follows: (first row) Johnny Kemberling, Amos Alonzo Stagg III, Glenn Shaffer, Luke "Dick" Bogar Jr., and Grant Rowe; (second row) Don Fisher, Jack May, Mahlon Rathfon, and George Hepner Jr. Those gray uniforms with maroon numerals were still around in the late 1950s.

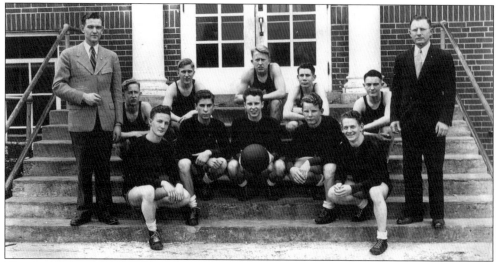

The McClure High School Trojans basketball team competed in the Snyder County League before consolidation merged several schools into West Snyder in the 1950s. Members of the 1945–1946 team are, from left to right, as follows: (first row) manager Ronald Bubb (standing), Roy Swanger, Ken Wagner, Norman Kline, Ellsworth Dean, Silas Dillman, and coach Sherman Good (standing); (second row) Jack Knepp, John Snyder, Gerald Knepp, Don Baker, and Joe Hassinger. The Trojans outscored their opponents 483-327 that season.

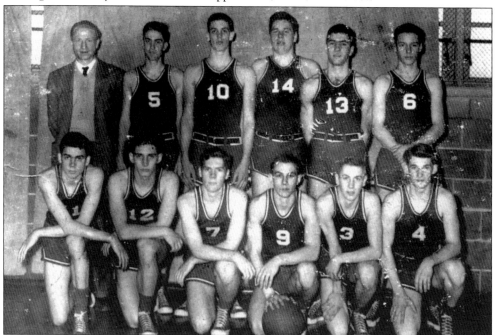

A group of fine younger athletes comes along only occasionally. Such a group matured into a great basketball team at Selinsgrove High for the 1949–1950 season. Coached by Blair Heaton, the Seals won the Susquehanna Valley League championship. From left to right are the following: (first row) Tommy Slayback, Billy Rowe, Ned Long, Ronnie Day, Dick Kretz, and Marvin Bonawitz; (second row) Coach Heaton, Johnny Robinson, Jack Keller, Rupe Leohner, Ken Fahnestock, and Marty Hughes. Missing from the photograph is Lloyd Bailey, the statistician.

The Selinsgrove faculty hoopsters played mostly for the fun of it, but sometimes took on basketball teams such as the Harlem Magicians and those of NFL teams. Members in 1951 are, from left to right, as follows: (kneeling) Steve Jaworek, Bill "Bud" Mease, and Chet Rowe; (standing) Dick Smoker, Bob Shadle, Blair Heaton, Charlie Fasold, Hank Troxell, and Ken "Rocky" Borst.

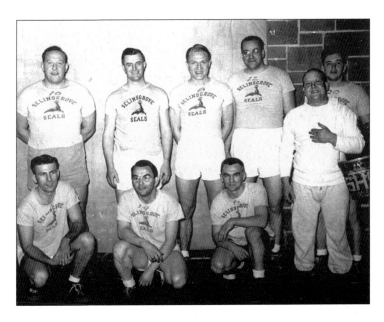

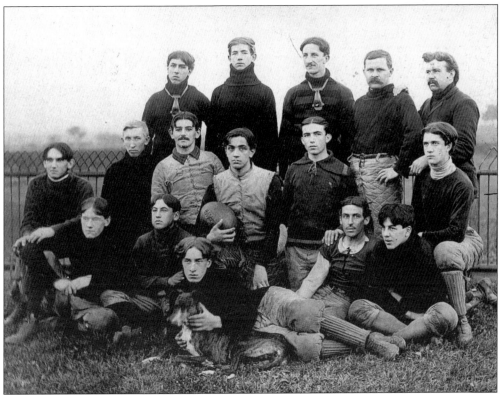

Noted on this photograph is "Susquehanna U. 'scrubs' - 1899." Only one player is identified, but not fully. At the extreme right in the second row is "Uncle Mack, Mother's brother." Now might be the time to make a plea to readers to dig out those treasured family pictures and mark them—completely, please—for future generations. Full names, dates, and locations, if known, would be most helpful—thank you.

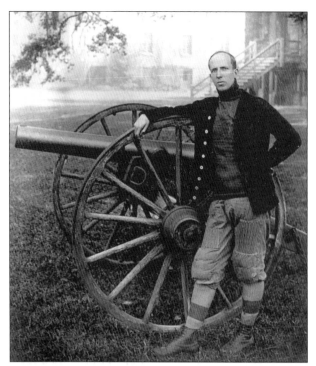

Edgar Wingard is one of the forgotten sports legends of Snyder County. He was outstanding as a football player at Susquehanna University with the class of 1902, but as a coach he had a truly remarkable record. At Louisiana State University, where this photograph was taken, he led the Tigers in 1908 to their *only* undefeated season between 1893 and 1959. His Bucknell team of 1918 was also undefeated. He also coached at Maine, and was an assistant to Carlisle Indians legend Glenn S. "Pop" Warner.

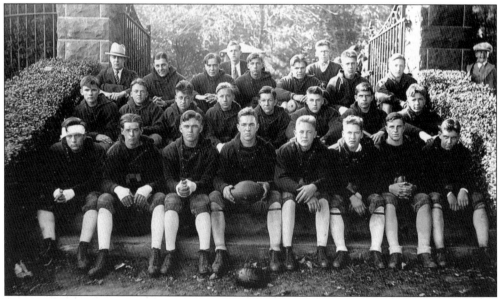

Harold L. "Pete" Bolig developed a football juggernaut at Selinsgrove High School. In the first three and a half seasons the coach's record was 27 wins, 0 losses, and 3 ties. His 1929 team, shown here, was 8-0-2. Team members are, from left to right, as follows: (first row) M. Long, A. Groce, R. Brouse, captain R. Fisher, D. Forster, S. Rishell, B. Shadle, and G. Oberdorf; (second row) H. Swope, M. Kahler, I. Coldren, C. Houtz, C. Rauch, F. McLain, J. Sholley, and M. Wentzel; (third row) Coach Bolig, R. Bolig, J. Kahler, W. Maginnis, T. Reigle, R. Kerstetter, and R. Johnston; (fourth row) managers M. Starr and F. Hoffman. The youngster at the extreme right is thought to be Marshall "Bud" Herman.

It is doubtful that any coach in any sport was more revered than Selinsgrove High's Tom Valunas, shown in 1945. Those fortunate enough to have played for him still speak of "Coach" with a special and well-deserved reverence. His integrity and profound goodness had a lasting effect on his charges. As SHS football coach from 1943–1948, he produced the Seals' only winning season (1943, 6 wins-1 loss) between 1935 and 1953.

Before Title IX allowed for equal rights in sports, girls were unfairly limited in what activities they could participate. One of those few activities was cheerleading—an outlet for athletic enthusiasm. Shown here are the Selinsgrove High School cheerleaders of 1950. From left to right are Margie Lamon, Corrine Smith, Pat Hughes, Helen Redcay, Jackie Brungart, and Kay Bolig.

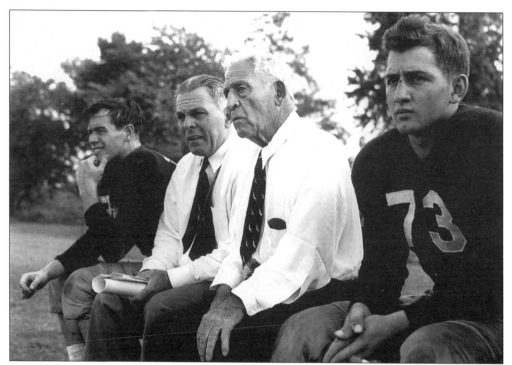

The name Amos Alonzo Stagg, it could be argued, is the most famous in all of college football. During a coaching career that spanned over three-quarters of a century—longer than Joe Paterno!—Stagg Sr. was known as the "Grand Old Man of Football." When he joined his son A. A. Jr. at Susquehanna University in 1946, Snyder County became a prominent location on the college football map. The Staggs—Jr. and Sr.—are flanked by players Bob O'Gara (left) and Dick Burley.

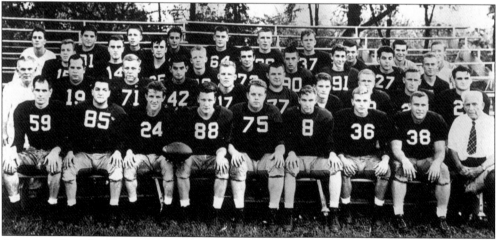

As co-coaches, the Staggs produced an undefeated, untied season at Susquehanna in 1951. Team members are, from left to right, as follows: (first row) Porter, Torromeo, Fenstermacher, Hazlett, Carr, Pritchard, Lenker, Walters, and Stagg Sr.; (second row) Stagg Jr., Shamp, McNamara, Tkaczyk, Balchen, Szabo, Young, Flowers, Torok, and Brouse; (third row) Livermore, Takach, Danyluk, Ross, Stamfel, Dell, Erdley, Davis, and Campbell; (fourth row) Boyle, Caruso, Thomas, Anoia, Beckley, Rising, Schwab, Dickovicky, Kurtz, and Lengel.

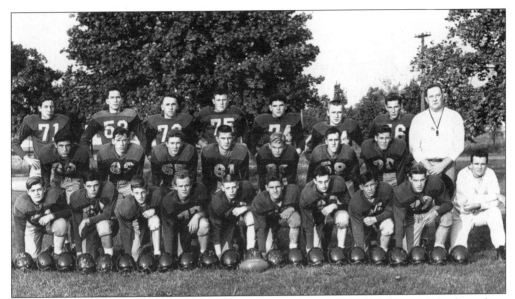

Selinsgrove coach Tom Dean had 15 Seals players on August 18, 1953. They, and a few others added once classes started, produced a winning season (the first since 1943) and Selinsgrove's first victory ever over archrival Sunbury, 14-0. Members are, from left to right, as follows: (first row) V. Wolf, B. Yerger, D. Eichenlaub, A. Zerbe, J. Campbell, J. Keiser, D. Hane, L. Nichols, B. Hoover, and Dean; (second row) B. Hare, H. Hoffman, D. Keller, C. Hower, B. Gargie, J. Gemberling, and A. Tompkins; (third row) G. Bingaman, M. Hoffman, B. Trutt, W. Mengel, D. Moyer, C. Bailey, B. Lewis, and coach Dick Smoker.

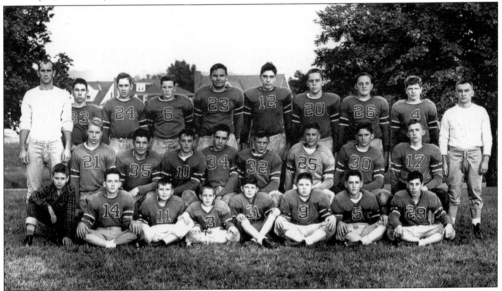

Begun in 1950, the Selinsgrove Junior High football program is a great feeder system to the varsity team. Members of the 1953 squad are, from left to right, as follows: (first row) J. Youngman, N. Rhoads, P. Harro, B. Shuker, J. Tompkins, D. Snyder, C. Grove, and D. Gaglione; (second row) H. Kantz, D. Beaver, G. Walter, L. Higgins, W. Starr, R. Ramer, D. Wendt, and D. Beaver; (third row) coach Jack Loudenberg, J. Hartley, R. Naugle, G. Hoffman, J. Kissinger, G. Hilbert, R. Conrad, D. Heiser, S. Leitner, and coach Chet Rowe.

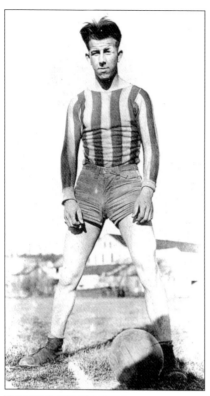

With the exception of Selinsgrove, high schools in Snyder County all played soccer in the fall. Middleburg had one of the earliest and most successful programs. An important player was Brite Bilger, shown here in 1930. Bilger and the Middies of that year were Snyder County League champions. Bilger was also an outstanding baseball player. He was on a Middleburg West Branch team that played Connie Mack's barnstorming Philadelphia Athletics of the American League in 1932.

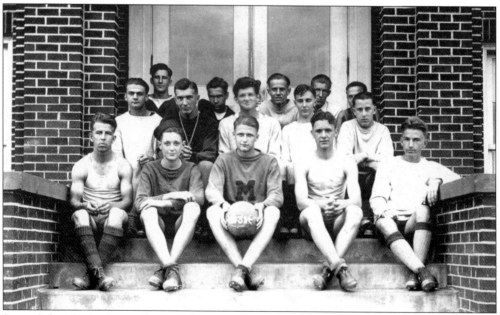

Several decades back, youth soccer became very popular in the county. However, it was not something new. Soccer had been played here for years. An example of this is the 1931 Middleburg High School squad, the defending Snyder County League champions. Unfortunately, only two players are identified: Brite Bilger (front row, extreme left) and Ken Badger (back row, second from the right).

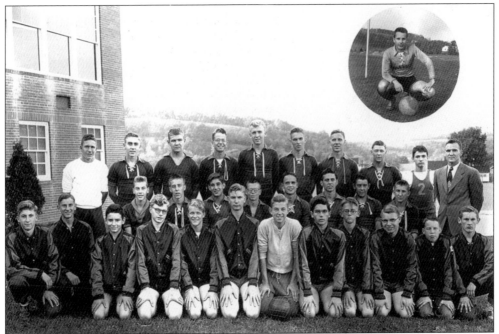

The size of the squad tells how much soccer meant to McClure High in 1952. The Trojans are, from left to right, as follows: (first row) K. Heimbach, G. Baker, G. Crawford, J. Reitz, M. Dodd, B. Albert, R. McGlaughlin, R. Stumpff, G. Wagner, D. Krick, R. Bratton, and B. Erb; (second row) D. Baker, D. Moser, B. Morgan, D. Snook, J. Weader, L. Gass, J. Folk, and L. Erb; (third row) J. Ballentine, M. Klinger, G. Crawford, B. Weader, D. Gilbert, P. Hockenbrock, G. Berryman, K. Hoffman, N. Boonie, and coach Harry Startzel; (inset) Norman Kline, assistant coach.

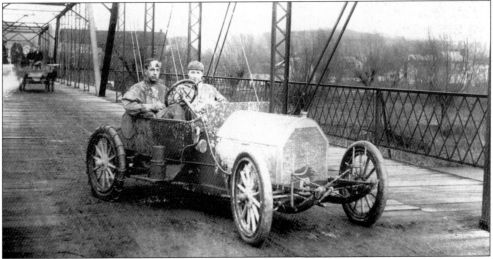

Just as space exploration captures young imaginations today, automobiles were all the rage in the early 1900s. With few paved roads, daring young men drove their machines wherever they could. George "Yarrick" Schoch, at the wheel of a sporty—if mud-splattered—1912 model and his friend stop on Selinsgrove's Pine Street Bridge after a presumed run on Front Street along the Susquehanna River.

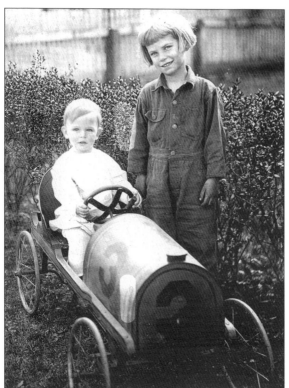

Pictured as a youngster is Selinsgrove resident Bob Burns and a pit crew consisting of his sister Barb. Toy cars of this nature, although seldom as elaborate, allowed boys' imaginations to run wild. Modern-day NASCAR fans will be quick to notice that Master Burns is at the wheel of No. 3 in the 1920s photograph. Can one assume that he intimidated his youthful rivals?

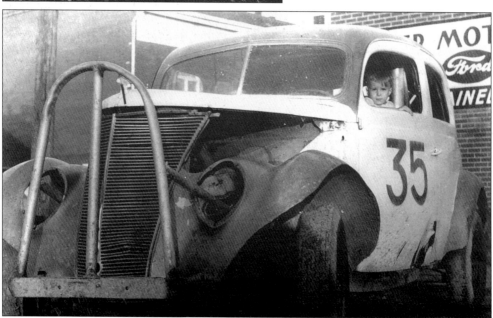

Most boys grow up interested in sports and cars—some, in both. In Snyder County, boys could have it both ways—there were lots of sports and the Selinsgrove Speedway came alive on weekends to the not-so-gentle hum of engines. "Bo" Fasold of Selinsgrove was a lad bitten by the racing-car bug. He is shown in 1953 behind the wheel of the No. 35 Ford coupe of Bobby Peck, parked behind Benner Motors at Market and Mills Streets.

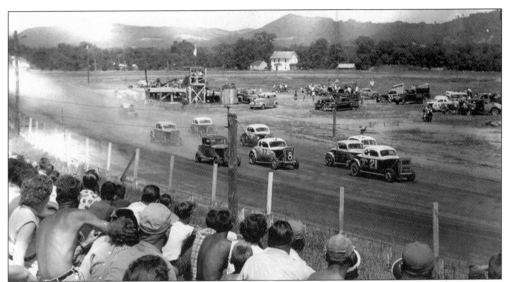

Auto racing at Selinsgrove Speedway dates back over a half-century, to 1946. Pictured are some of the earliest stock cars. Fans flocked to see their favorite cars and drivers. Famed Indianapolis 500 race announcer Chris Economaki broke into racing at Selinsgrove in 1949, the year this photograph was taken. Local racing talent included Barry Camp, who listed his hometown as both Troxelville and Beavertown, and later, Paul Long of Middleburg. Selinsgrove earned a reputation as one of the fastest half-mile tracks anywhere.

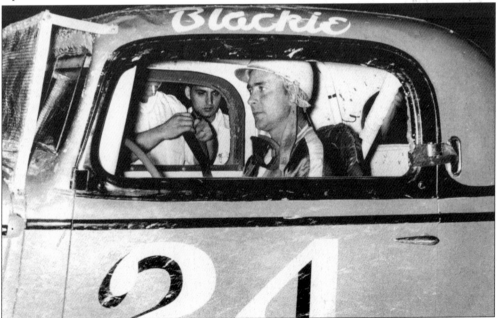

"Blackie" Balliet was just one of many Selinsgrove Speedway drivers who had a large and loyal following in the 1940s and 1950s. Others included Vic Nauman Jr., Johnny Crawford (in his Craw-Ford), Wilbur Reese, and Harlan "Cat" Fisher. The speedway shut down for several years before racing resumed there in 1963. The new era brought new names to the scene: Ray Tilley, Dick Tobias, Leroy Felty, Mitch Smith, Ed Spencer, Lynn Paxton, and Bobby Adamson. Jan Opperman, at least once, took time off from Selinsgrove to drive in the Indy 500.

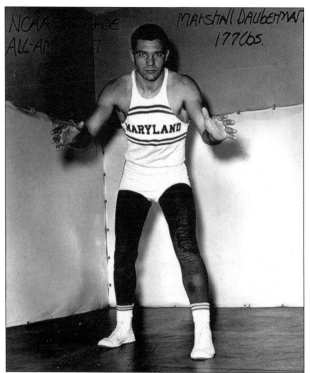

When Selinsgrove High School started a wrestling team in 1957 coached by Dick Smoker, Marshall Dauberman of Kratzerville proved to be a natural. He was strong, tough, and dedicated. His huge, powerful hands helped. Smoker told someone during Marsh's senior year in 1959, "I wish I had that Dauberman boy back next year. I think I could make him a state champ." At 177 pounds, Marsh became a state champ *that* year! He went on to the University of Maryland, where he was all-America and three-time Atlantic Coast Conference champion.

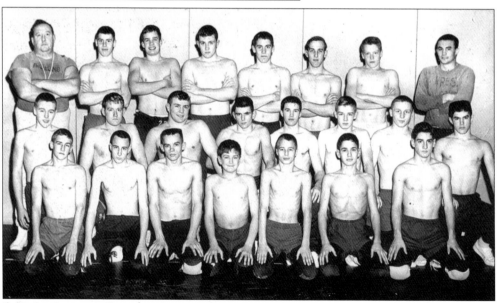

Dick Smoker—a college grappler at Millersville—became a legend after bringing the sport to Selinsgrove. This is his 1961–1962 team, outfitted in dyed long johns and gym shorts (and without tops). Team members are, from left to right, as follows: (first row) D. Ulrich, L. Manley, L. Lenig, D. Setter, W. VanNuys, W. Gill, and B. Miller; (second row) C. Dauberman, B. Knouse, D. Barlett, E. Benfer, B. Mease, D. Horne, J. Beaver, and G. Hummel; (third row) Coach Smoker, R. Burgard, C. Dounce, W. Groce, L. Burgard, P. Gemberling, T. Burgard, and assistant coach Glen Davis.

94

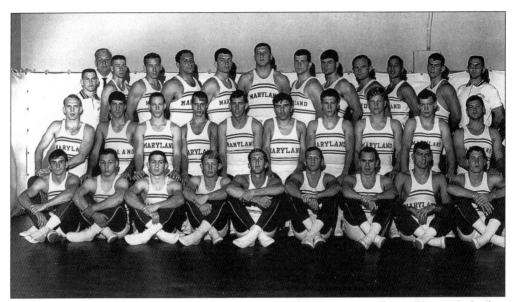

Selinsgrove's Marshall Dauberman, after being a state champion, earned an athletic scholarship to the University of Maryland in 1960. He paved the way for other Snyder County wrestlers on the Terps squad. The 1966–1967 Maryland team featured three county grapplers: shown in the second row, fourth from the left is Walter "Bowie" VanNuys of Selinsgrove; in the second row, third from the right is Gobel Kline of West Snyder; and in the third row, fourth from the right is Bob Walker of Selinsgrove. Kline was the 1969 NCAA champion at 157 pounds.

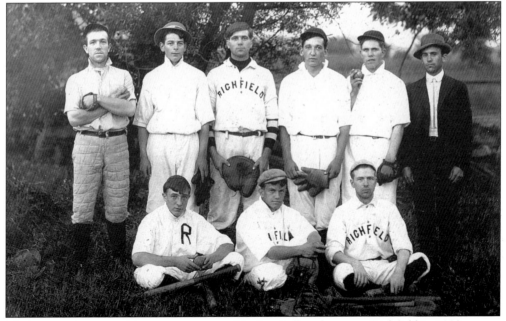

Many county communities were represented by baseball town teams. Richfield in 1908 was no exception. Team members shown in this sharp photograph are, from left to right, as follows: (seated) Russ Graybill, Ira Miller, and Oscar Deckard; (standing) Banks Neimond, Art Snyder, Ira Mitterling, Ed Dunkelberger, Tom Spriggle, and Steve Mittlerling. There is no record of how the boys did, but they do look like worthy opponents.

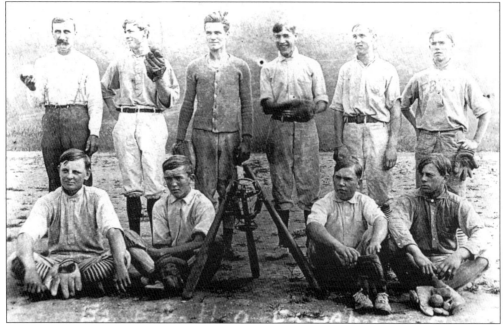

Is there any doubt that by the beginning of the 20th century, baseball was the national pastime? This photograph of the 1903 Freeburg town team should erase any such uncertainty. The team's outfits may not be consistent—in fact, they may not even be official uniforms. But the expressions on the players' faces show determination, resolve, and a love of the game. As was traditional, a display of equipment serves as a focal point in the center of the team photograph.

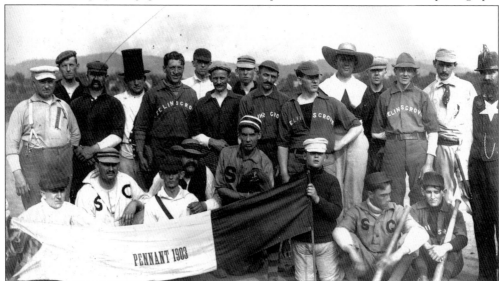

Although the players are not identified, the location and date of this photograph are certain—Selinsgrove, 1903. Historical material mentions games between the Fats and the Leans. Looking at players on the left and right, it is safe to assume this is one of those encounters. Perhaps this is a pre-game photograph as the pennant is about to be contested. One wonders how the team would fare against their 1903 Freeburg counterparts (previous photograph). The various headgear adds to a carnival atmosphere.

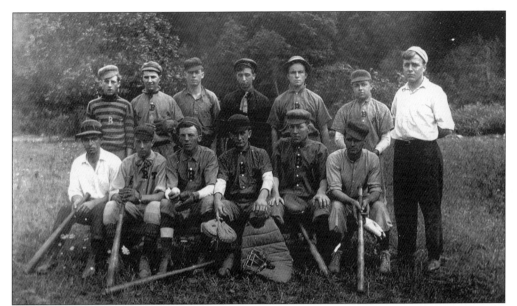

Documentarian Ken Burns did such a thorough job on PBS's multi-chapter *Baseball* series that nearly everyone now knows that most towns in America had baseball teams in days gone by. The surviving pictures invoke nostalgia. The 1909 Kratzerville team shown here is typical of the time period. Note the smallness of the gloves compared to today's peach basket–like mitts. Also take notice of the widely spaced K B T (Kratzerville Baseball Team) on many of the shirts.

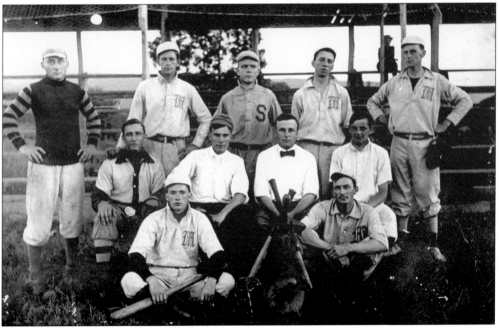

The preponderance of vintage baseball photographs in this chapter attests to the game being the national pastime. This Middleburg team poses for posterity in June 1909. The identification reads, from left to right, as follows: "First row, Ritter and C. Stetler. Second row, H. Brouse, Jack Mertz, umpire John L. Stahlnecker, manager S. Burns. Third row, R. Stetler, C. Runkle, R. Walters, J. Lupold, P. Grimm."

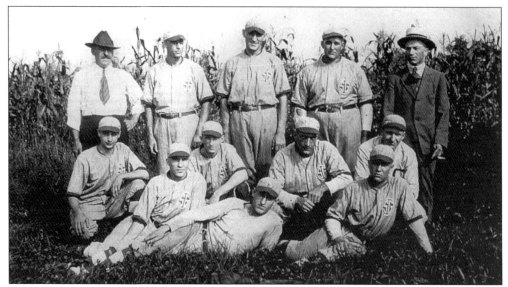

Town teams are as American as apple pie and Chevrolet. With the rigors of World War I in the past, the 1919 Selinsgrove team took the field. The style of uniforms and cornfield background are reminiscent of *Field of Dreams*. From left to right are the following: (first row) Bill Hare, Elmer Fisher, and Harold "Pete" Bolig; (second row) Al McClain, Thorne Schuck, Jack Herman, and Bill Dove; (third row) manager George Fisher, Leon Gaugler, Everitt "Cuffy" Bolig, Al Fisher, and coach Chet Ludwig. Yeager Shoe Company sponsored the team.

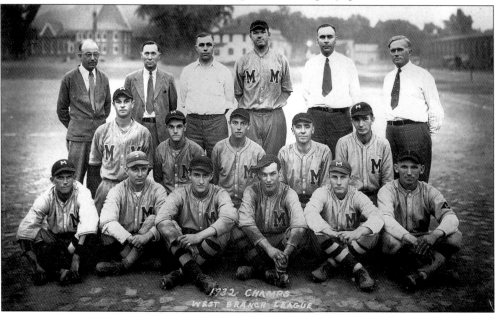

Not only did this 1932 Middleburg team win the West Branch League championship, but they also took on a group of major-leaguers (see next photo). Made up mainly of players from Connie Mack's Philadelphia Athletics, the barnstorming major-leaguers also included former big-league pitchers Howard Ehmke and Fred Frankhouse. Athletics second baseman Max Bishop was in the barnstormers' lineup as well. Known Middies pictured here are Percy Miller (front row, second from the left) and Bill Herman (second row, second from the left).

To close the 1932 season, Middleburg's West Branch team played a barnstorming exhibition game against Connie Mack's American League Philadelphia Athletics, who were just two years removed from a World Series championship. Playing at Middleburg, this snapshot shows Percy Miller of the Middies hitting the ball and heading for first. Miller was a longtime fixture as player and manager of Selinsgrove and Middleburg teams. Is it possible that the Athletics catcher is Hall of Famer Mickey Cochrane? Note the huge crowd.

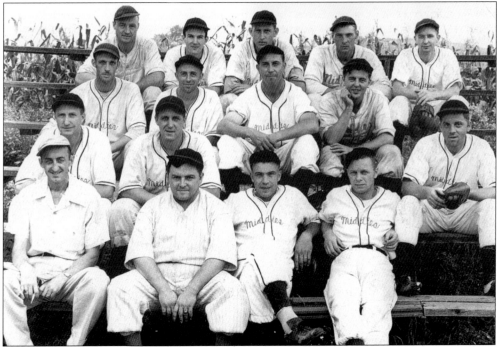

In another *Field of Dreams*–like photograph are the 1947 Middleburg Middies—the Lower Circuit West Branch League champs in 1947 with a 23-4 record. Team members are, from left to right, as follows: (first row) scorer Charlie Eisenhower, manager John Schuck, Bob Bachman, and Sam Hackenberg; (second row) Lew Solomon, Guy Snyder, and Charlie "Red" Steininger; (third row) Dick Howell, Ben Bachman, John Gift, and Dick Felker; (fourth row) Harold Neff, Dorr Stock, Paul "Spike" Stetler, Warren "Bud" Steininger, and Les Mitchell.

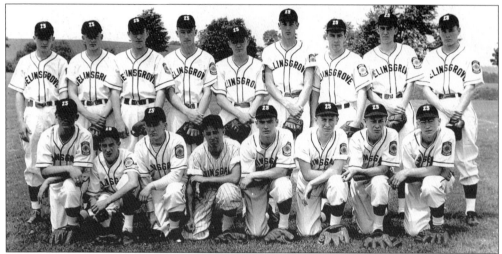

High school baseball may be iffy due to early spring weather, but American Legion ball provides another chance come summer. This 1949 Selinsgrove Victory Post 25 team was coached by Tom Valunas and went quite far in districts. Players are, from left to right, as follows: (first row) Jack Steffen, Kay Thomas, George Sheetz, Joe Emery, Tommy Slayback, Roger Hepner, Dick Kretz, and Elton Kauffman; (second row) Billy Rowe, Jim "Peanut" Bolig, Galen Campbell, Carl Winey, George Wilhour, Jack Keller, Donnie Foltz, Johnny Robinson, and Davis Clark. Missing from the photograph are Glen "Jake" Miller, Frank Troutman, and Donnie Botteiger.

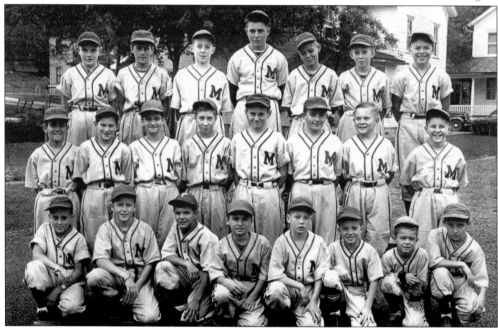

Little League Baseball took off after World War II. Players on the 1950 Middleburg team are, from left to right, as follows: (first row) Chip Kleinbauer, Billy Vought, Mike Herman, Bill Faylor, Roger Mitchell, Terry Libby, Tony Herman, and Nolan Jordan; (second row) Dick Bilger, Lenus "Peanut" Hestor, Larry Hummel, Rodney Klose, Paul Long, Larry Kratzer, Bill Gaskins, and Joe Erdley; (third row) Paul Ernest, Larry Arbogast, John Kaufman, Richard Kerlin, Harry Lesher, Gary Bickhart, and John Snyder.

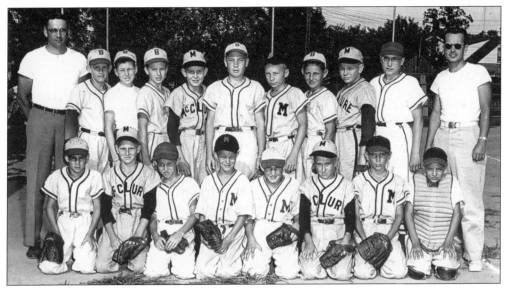

From humble beginnings in Williamsport in 1939, Little League Baseball spread worldwide by 1953, the year this photograph was taken of the Western Snyder County All-Stars. Team members are, from left to right, as follows: (first row) John Womer, Harold Flood, Larry Lepley, Tony Herman, Barry Ulrich, Dennis Knepp, Dave Reichenbach, and Jim Lesher; (second row) coach Howard Master, Ron Saylor, George Hassinger, Dale Hackenberg, Tony McGlaughlin, Jerry Wagner, Chester Hoffman, Willis Hackenberg, Douglas Kratzer, Lynn Knepp, and coach Norman Kline.

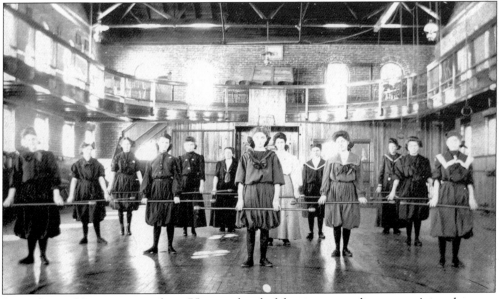

Susquehanna University was about 75 years ahead of the times regarding women's involvement in athletics. Title IX legislation was not enacted until 1973, but in 1895 the school was already co-ed with physical education opportunities for women. This 1909 photograph shows a physical education class in the old Alumni Gym. The women are about to perform exercises using lightly weighted sticks. Like many gymnasiums of the time, there is a suspended running track above and encircling the gym floor.

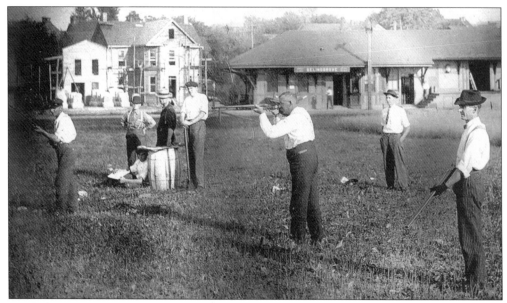

Snyder County residents have long believed strongly in the Constitution's Second Amendment and the right to keep and bear arms. Hunting, once a necessary pursuit, remains popular. So, too, is trapshooting. Shown, on the firing line, is a group of 1910 Selinsgrove trapshooters. From left to right are George Lumbard, an unidentified group of three men, Frank Smith, Luther Smith, and Hiram Seigfreid. The field is west of the still-standing train station. Note too, the McFall monument works.

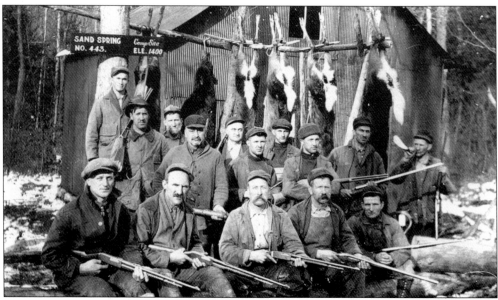

Since Joe Long (1799–1872) of Beaver Springs earned a reputation smithing Pennsylvania long rifles, hunting has been a sport and a livelihood in Snyder County. The deer-slayers pictured here in 1931 at the Sand Spring Camp in the Beaver Springs area are, from left to right, as follows: "(first row) Hurley Goss, Cal Goss, Steward Booney, Pharos Baker, and Charlie Fry; (second row) Isaac Wagner, Frank Wagner, Bill Wagner, Joe Wagner, Charlie Wagner, Art Goss, Les Goss, Sam Spigelmyer, Art Arnold, and John Spigelmyer."

Fred Reichley was many things to many people—shopkeeper, candy maker, ice cream maker, and jeweler—but mostly he was a friend. For rest and relaxation, he enjoyed nothing more than getting away to fish. Photographed at his favorite fishing hole along Penns Creek near the Camelback Bridge, Fred seems at peace with the world. The picture was taken by Charlie Fasold in 1942.

Residents of Snyder County, with access to some of the nation's best fishing venues, have pursued the pastime for years. Pictured in 1948 is Emory E. Snyder, a lifelong resident of Richfield, as he sets out under the watchful eye of Tippy III. Note the handmade bamboo pole and folding stool—a full day of fishing must be planned. Snyder, a rural mail carrier and active churchman, had 10 children, one of whom— Robert—operated a general store in Freeburg until 1989.

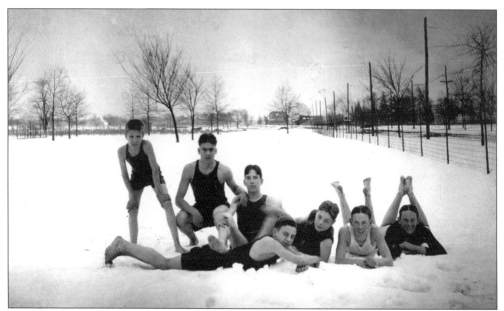

Schoolboys always do things that puzzle adults, such as stuffing as many boys as possible in a phone booth or a Volkswagen. This 1922 group poses in the snow in bathing attire. Could this be Harrisburg Academy's Polar Bear Club? Wilfred K. Groce of Selinsgrove is pictured fifth from the left with his schoolmates. His high school days were spent at the academy. So great was Willie's competitive fire that he was later inducted into Susquehanna University's Hall of Fame as a football and baseball player.

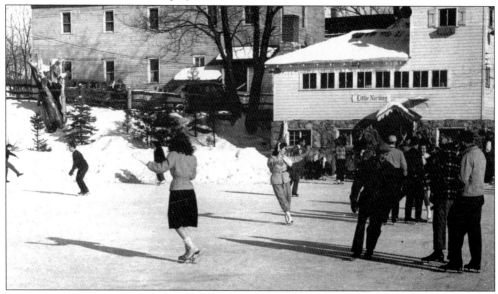

In 1938, the Burns family of Selinsgrove opened a skating facility called Little Norway. Contributing to the charm of the Isle of Que setting was a replica of a Swiss chalet. A wine cellar was added in 1942. Little Norway, pictured here in 1950, still holds a place in the memories of nearly all who skated there. In later years, Explorer Scout Post 2419 operated the rink. Each fall, before the rink was flooded for winter, it was often the scene of Ice Bowl sandlot football games. The facility closed in 1968.

Seven

HAPPENINGS

It has been said that Mother Nature is an accomplished artist, painting scenes of exquisite beauty. Never is this truer than when a fresh snowfall blankets the area. Charlie Fasold, creator of numerous pictures in this book, used his considerable skills to capture this enchanting, time-exposed scene in the winter of 1949–1950, showing the first block of North Market Street in Selinsgrove. Viewing the photograph, one can almost feel the crispness of the night and sense the silent stillness.

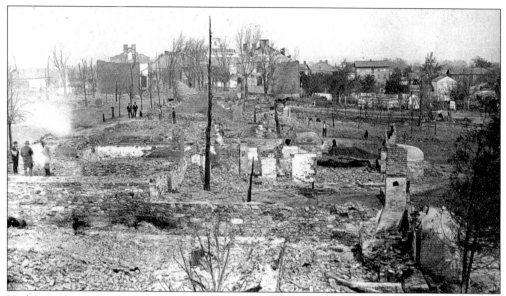

Had it not been for the disastrous fire in downtown Selinsgrove that broke out about 6 p.m. on Wednesday, October 28, 1874, the town would have an even greater number of charming old buildings. Fifty-four homes and businesses were lost. This Roshon & Richie photograph is eerily reminiscent of one of Matthew Brady's Civil War photographs of a Sherman-devastated Atlanta. The Noetling Building in the background survived, as did the Governor Snyder Mansion, although it was somewhat damaged.

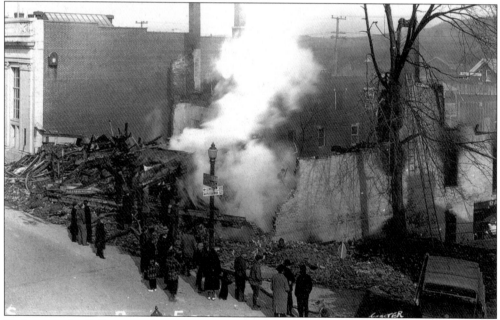

Unfortunately, Selinsgrove is no stranger to fires, as are many Snyder County towns. The Tuesday, February 15, 1938 fire at the northeast corner of Market and Walnut Streets took two lives and caused heavy damage, completely destroying the Hendrick & Decker Building. A service station—at one time Jarrett & Seachrist Sunoco—was built shortly after the debris was cleared. The area seen in this Feaster photograph is now the location of IT 'Xpress pizza shop.

The fire at Bogar Lumber's Selinsgrove yard on Saturday, April 11, 1946, is what officials call "fully involved." Flames and smoke billow from the structure's openings. Heat is intense, and brave firefighters—the Hookies and others—can only hope to contain the fire and keep it from spreading. They were quite successful in that regard. The North Water Street business was quickly rebuilt and reopened.

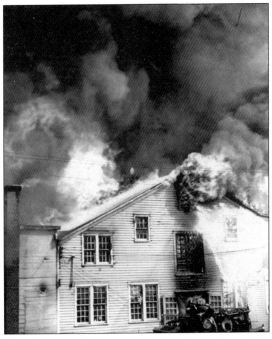

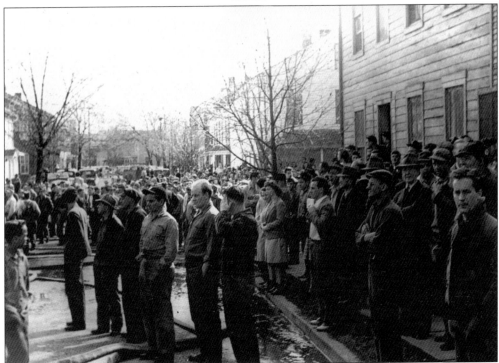

An otherwise pleasant spring Saturday afternoon of April 11, 1946, was marred by the fire at Bogar Lumber's facility on North Water Street in Selinsgrove. Bystanders—several hundred of them—could only stand by helplessly to watch and hope for the best. Identifiable onlookers are Elmer Groce (fourth from the left in baseball-type cap, standing with the group of six men in the middle of the street) and Sephares Gemberling (on the curb, at right, with arms folded).

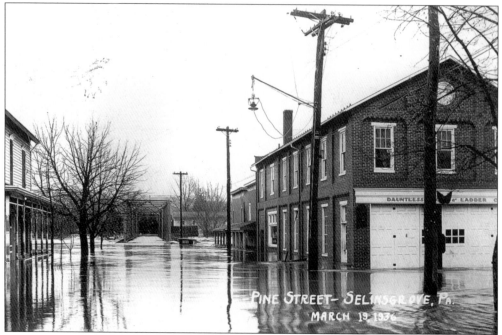

While all of America coped with the Great Depression, Pennsylvanians—and others who lived near water—had their lives complicated by floods in March 1936. Flooding from the Susquehanna River was especially damaging. Not a town or city along the river and its north and west branches escaped unscathed. This deceptively tranquil scene is at the intersection of Pine and Water Streets in Selinsgrove. Note the water level is even with the roadbed of the Pine Street Bridge.

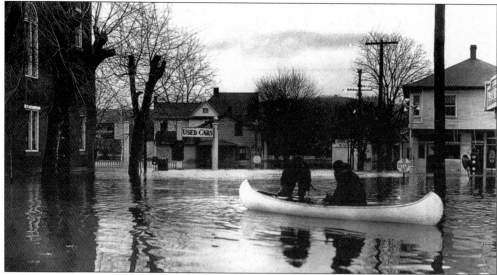

Mention "the year of the flood," and a generation of Snyder County residents knows that the year was 1936—or at least they did until 1972. Throughout much of the country, spring flooding wreaked havoc. This Selinsgrove couple on Thursday, March 19, 1936, uses one of the only viable means of transportation available. Their canoe is at Market and Mill Streets. Note how high the water level is at the stop sign. St. Paul's United Church of Christ is on the left.

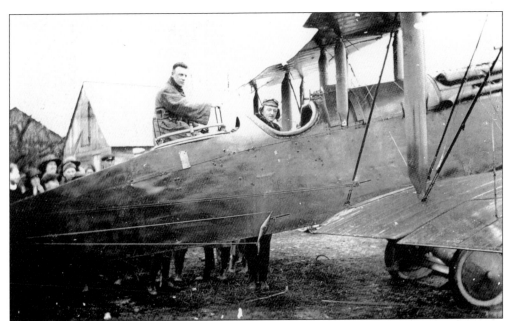

Once the automobile became commonplace, aviation became the new frontier. After aero-aces returned from World War I, they had few options. Barnstorming with flying circuses was one possible pursuit, and piloting airmail planes was another—though both were dangerous. Shown is an airmail pilot—not Charles A. Lindbergh—and his co-pilot on the morning after foul weather forced them down in a vacant field east of Middleburg. Note the considerable crowd behind the Jenny aircraft. The photograph dates back to 1925.

At the time they were built, covered bridges were considered innovative. The cover, or the roof and sides, prevented the heavy timbers that made up the roadbed from rotting or weakening. This 1920s photograph plainly shows that eventually the timbers could no longer hold up to the task. A fully loaded, solid-tire truck broke through the floor of this bridge and into Middle Creek between Globe Mills and Meiser.

Train wrecks are always scenes of devastation and confusion, and this photograph illustrates that explicitly. The derailment shown here took place at the Blue Hill Bridge (which is no longer standing) in the Shamokin Dam area on Thursday, January 30, 1936, shortly after midnight. The bitter cold and falling snow that night hampered rescue efforts. Three lives were lost in the wreck and explosion of the *Williamsporter*, and another 33 people were injured. Doctors, nurses, and volunteers worked unstintingly through the night.

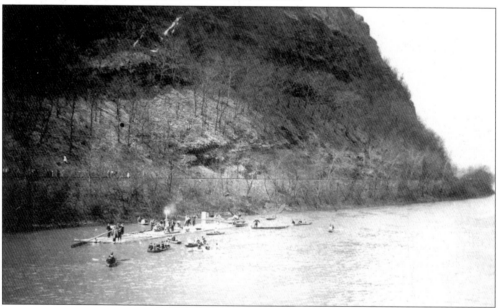

During the 1800s and early 1900s, lumbering in the Northern Tier of Penn's Woods was big business. Millions of board-feet of lumber were floated down the Susquehanna River on rafts. The symbolic "Last Raft" floated by Blue Hill in the Shamokin Dam area at 11:30 a.m. on Wednesday, March 23, 1938. Seven people had died when the raft hit a railroad bridge pier in upriver Muncy. As a tribute to those lost, the 80-ton raft completed its journey to Harrisburg, stopping overnight in Selinsgove on the way.

Eight

A COUNTY OF JOINERS

Snyder County residents have always banded together. During World War II, all Americans joined in effort as never before—and some would say, as never since. Vocabularies increased with phrases such as "for the duration," "Nambu machine gun," and "Norden bomb-sight." Boy Scouts collected newspapers and other material, but the really big effort seemed reserved for the collection of scrap iron. The results of an October 1942 drive can be seen at Selinsgrove's Pine Street School. Teacher Ray Soyster (wearing a suit) is seen at the center of the photograph.

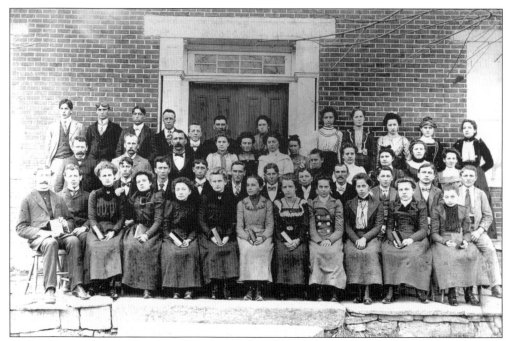

At first glance, this may appear to be a group of students from another one-room schoolhouse. It is actually a catechetical class at St. John's Lutheran and Reformed Church in Mount Pleasant Mills. The 1901 class—the largest in church history—was taught by the Rev. C. C. Miller, seen at the far left in the first row. Unfortunately, he is the only person identified in the photograph.

Snyder County residents' history of service to their country goes back to the earliest times. When the Civil War ripped the nation asunder, many answered the call of duty. On Tuesday, September 13, 1862, Company G of the 147th Regiment left for the front and served with honor and distinction, as their banner indicates, at Chancellorsville, Gettysburg, Lookout Mountain, Peavine Creek, and other theaters of operation. Shown here in 1915 (also on September 13), the veterans held reunions at Rolling Green Park and the McClure Bean Soup.

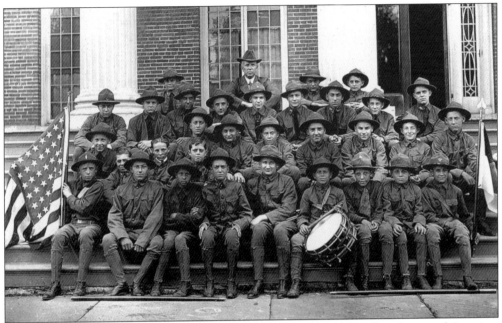

These are not World War I doughboys. They are Selinsgrove's first Boy Scouts of America, Troop 9. The Scout commissioner is civic-minded Edgar Wingard, seen in the middle of the back row. Taken in 1918—Scouting started in England a little earlier, and was brought back to the United States by returning World War I veterans—this photograph shows the boys assembled on the steps of Susquehanna University's Seibert Hall. Garfield Phillips (fourth row, third from the left) and Billy Schnure (to the right of Wingard) were Scoutmasters.

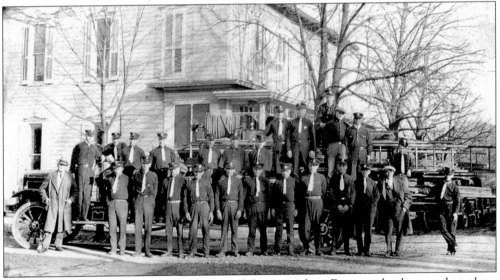

The history of Selinsgrove is marked by several disastrous fires. Fortunately, the town has a long history of firefighters as well. Very early on, a pumper, the Arrow—built in Philadelphia in 1764—was brought to town. The pumper is now on display in the State Museum of Pennsylvania in Harrisburg. Eventually, the Dauntless Hook & Ladder (the Hookies) was formed on October 24, 1874, not long after a major Selinsgrove fire. Like other companies, the Hookies often paraded. Here they are in 1926 in their dress blues.

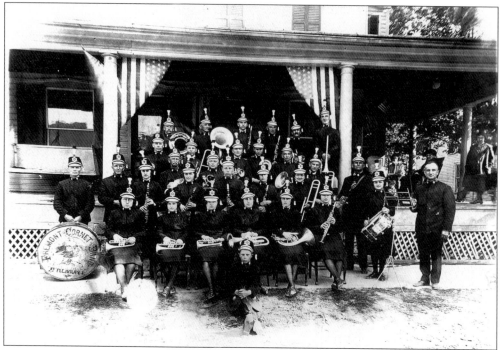

The Fremont Cornet Band, shown in 1924, in earlier years played for "$8.00, dinner, and horse feed." The group's bandwagon was pulled by horses. Members are, from left to right, as follows: (in front) R. Mengel; (first row) M. Heim, M. Garman, E. Shaffer, M. Howell, M. Brosius, and S. Boyer; (second row) H. Mengel, J. Shaffer, H. Kreighbaum, G. Arbogast, A. Gingrich, D. Mengle, E. Bottiger, J. Boyer, and conductor J. Kreighbaum; (third row) P. Schnee, J. Arbogast, M. Moyer, A. Botdorf, O. Kaltriter, R. Kreighbaum, L. Moyer, and W. Brown; (fourth row) W. Smith, A. Shadle, A. Boyer, L. Shadle, A. Garman, and C. Bottiger.

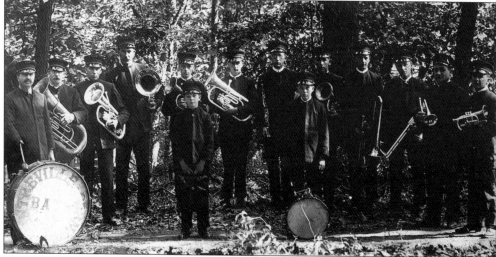

Due to the fact that there were several Centrevilles in the state, the Snyder County village of Centreville changed its name to Penns Creek—but not before the cornet band was formed in 1879 by John Shinkle. Minnie Stuck once related, "The cornet band played at all local outdoor summer events, and sometimes for an out-of-town picnic or cake-walk." The band is seen c. 1910.

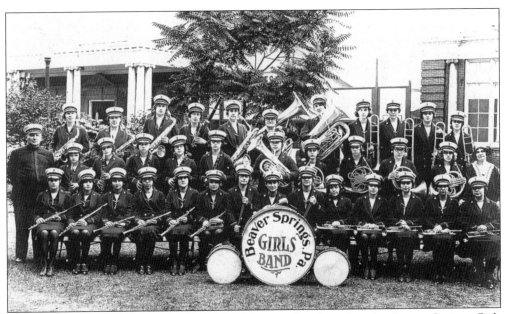

Sharp eyes will recognize this as the cover photograph—featuring the Beaver Springs Girls Band of 1929. The longstanding band was formed on July 8, 1918, under the able direction of Palmer Mitchell. The band traveled far (three days at the Canadian Exposition in Toronto in 1930) and near (the neighboring McClure Bean Soup), logging more than 25,000 miles over the years. The musicians brought fame and honor to Snyder County. It was the first band of its kind in the state and the first female band to have full uniforms.

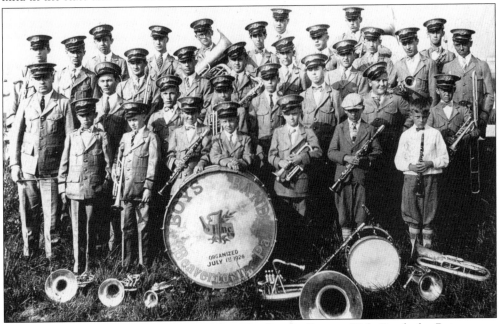

A logical complement (and compliment) to the Beaver Springs Girls Band, the Beavertown Boys Band was formed on Thursday, July 1, 1926. Shown here, not long after it was first established, are band members and their instruments. Note the two youngsters at the right end of the first row—they apparently are too new to the group to have been issued uniforms.

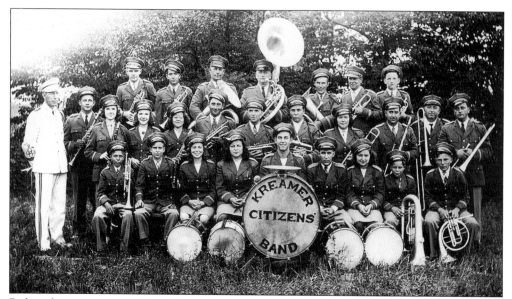

Before there were two cars in every garage, people tended to stay within the confines of their community the majority of the time. Entertainment was generated locally in most cases. Among the ramifications of this were the numerous bands that were staffed by local talent. The Kreamer Citizens' Band, with 27 members, is shown in 1933, and is typical of such a community organization.

Though they are posed in front of their Susquehanna University fraternity house instead of with their instruments, this group of student-musicians played their way across the Atlantic in the summers of 1935 and 1936. The men, who provided music for four different Cunnard-White Star ocean liners are, from left to right, Pete Poyck '37, Frank Bennardi '35, Jake Newfield '35, and Rudy Gelnett '37. Gelnett enjoyed a long musical career, becoming an entertainment fixture in Snyder County and the vicinity.

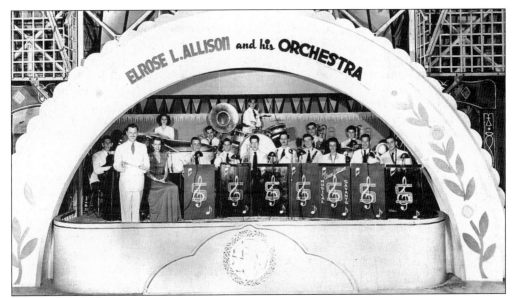

Elrose Allison succumbed to a ruptured appendix at too young an age in 1946, but he left a great musical legacy. As bandleader, he and his Musical Savants were often the house band at Rolling Green Park. Shown in 1946 are, from left to right, the following: (group at far left without music stands) Ray Conrad, Elrose Allison, Holly Wand, and Jeanne Ludwig; (front row) Marlin Fisher, Art Bickhart, unidentified, ? Haidecker, unidentified, Bob Troutman (second from the right), and unidentified; (back row) unidentified, Jackie Fritz, unidentified, and Ken Mease.

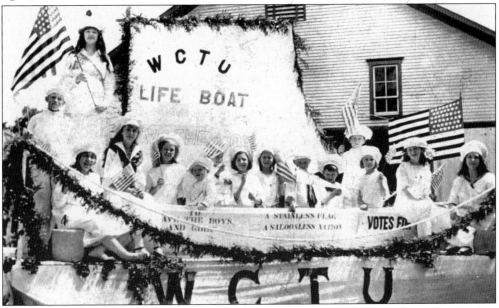

The Women's Christian Temperance Union (WCTU) was formed nationally in Cleveland in 1874. The union's objective was to persuade all states to prohibit the sale of alcoholic beverages. Frances E. Willard and Carrie Nation were early leaders of the movement. The local WCTU group, which was formed in 1913, was headed for many years by Mount Pleasant Mills resident Dorothy Mengle Botteiger. Shown in a 1930s county Fourth of July parade is a WCTU lifeboat advocating a "Saloonless Nation."

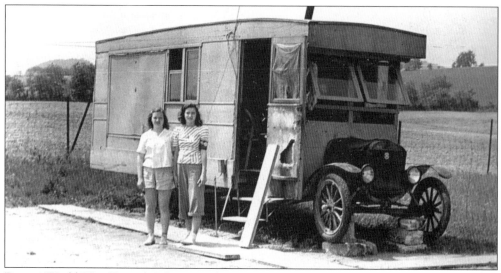

During World War II, civil defense—a forerunner to homeland security—was everyone's job. Some were more involved than others. Two of the involved, as airplane spotters, are cousins Beth Ruch (left) and Genevieve "Gibby" Dagle, shown here in June 1942. The vintage 1913 modified truck, which does not seem to be going anywhere anytime soon, is located on the campus of Selinsgrove High School. Note Gibby's official CD armband.

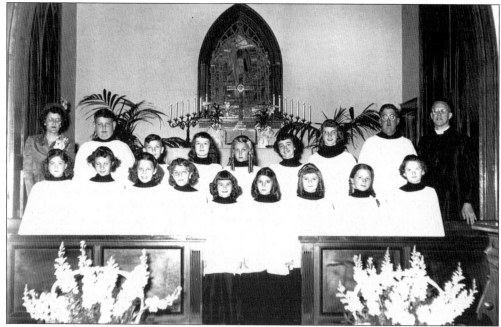

The junior choir is assembled on Easter Sunday, April 18, 1949, at the Trinity Lutheran Church. The building is now the home of Selinsgrove's Lafayette Masonic Lodge No. 194 F&AM. Shown here are, from left to right, the following: (front row) Abigail McLain, Carolyn Shaffer, Carol Heller, Janet Ulrich, Carleen Keyser, Linda Charles, Nancy Lee Adams, Kitty Hall, and Beverly Ritter; (back row) director Mildred Rishell, Charlie Bickhart, Dale Bickhart, Janet Raudenbush, Iliana Zagars, Joan Raudenbush, Alice Louise Valsing, Clayton Leach, and Rev. John Heller.

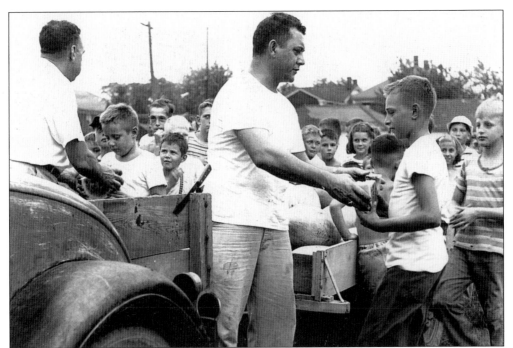

Was there ever a kid in Snyder County, or anywhere, who did not like watermelon? Members of Selinsgrove Moose No. 1173—"Pete" Youngman (left) and Art Sprenkle—distribute the summertime treat from the back of Bob Shadle's Ford Model A "pickup" truck. Identified children are, from left to right, Ken "Lug" Thomas, Art Schuck, Stan "Goat" Nace, Jay Wagner, Gene Shotsberger, Jerry Schuck, Jane Schuck, Nancy Stuck, and Dick Eichenlaub. Taking a direct handoff from Sprenkle is Fred Fry.

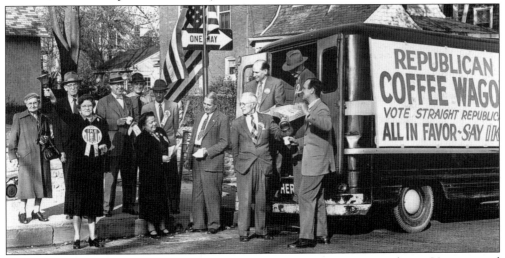

It was once said that nationally, the Republican Party could count on two things: Vermont and Snyder County. The numbers narrowed over the years, but GOP registration still overwhelms the opposition. This 1952 Middleburg photograph shows the GOP in full campaign mode. As signs indicate, Ike is well-liked. People identified are, from left to right, as follows: (front row) Violet Leslie, Mrs. Rishell, Arthur Biers, Herb Straub, and Joe Bullen; (back row) Florence Boley, Frank Titus, Mr. Paul, Jack Graham, Joe Young, Mr. Dinkhous, and Clarence Cox.

The Philathea Class of St. Paul's United Church of Christ in Selinsgrove thought so much of Carrie Bogar that after she was transferred to the Dutch Pantry in State College, the members chartered a BKW clipper to visit their ex-classmate on Tuesday, June 23, 1953. BKW Coach Line, in addition to providing service between Sunbury and Selinsgrove, had a flourishing charter business, and bussed hundreds of school kids 180 days a year. The coach line's personable drivers were regarded as almost family. Note the curious youngster with a toy car in hand.

The General Grand Chapter, Order of the Eastern Star, is an adjunct to Freemasonry. It was formed as a counterpart to the Masons, and prospective members had to be 18 years old and related to a Master Mason in good standing. Pictured wearing customary white gowns and corsages is the newly installed May 1955 class of Lafayette Chapter No. 22, Order of Eastern Star from Selinsgrove.

Nine

We Observe
and Celebrate

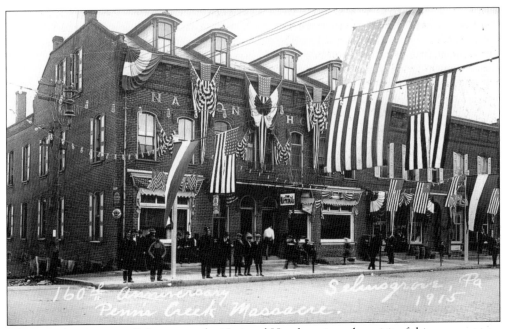

Like many businesses in Selinsgrove, the National Hotel got into the spirit of things once town historian William M. "Billy" Schnure got the ball rolling to mark the 160th anniversary of the Penns Creek Massacre in 1915. All the town was decorated, but the National was especially festive. The restaurant was later operated by Bob Mease's family at Market and Chestnut Streets, and the building had several facelifts over the years before it was ultimately destroyed by fire on August 17 and 18, 1990.

When Selinsgrove celebrated the 160th anniversary of the Penns Creek Massacre on October 14–16, 1915, Billy Schnure and his associates pulled out all the stops. A major event was the crowning of the queen on a special platform on Market Street, in front of the Keystone Hotel (now BJ's). Mary Elizabeth Woodruff (center) was chosen. The queen's graces, or court, include Carrie Wetzel and Mary Burns. Several youngsters serve as attendants. Later the crowd gathered and dedicated an historical marker at a site along Penns Creek.

Perhaps the most longstanding tradition in Snyder County is the McClure Bean Soup. It began in 1891 as a reunion of Civil War veterans and continues today. Shown in 1911 are eight steaming kettles of bean soup, made according to a recipe dating to the Civil War. Tending the kettles are, from left to right, James Weader, Charles Baker, and John E. Wagner. Partially obscured (at center) is Frank Bowersox. Through the years, the McClure Bean Soup has been the kickoff of the Republican campaign, with governors and senators attending.

"Jumping on the bandwagon" refers to those latecomers to an established cause, but it was not always a figure of speech. Before there were Silver Eagle tour buses, many bands had their own wagons, as evidenced by this photograph of the Troxelville Band. The photograph was taken in McClure in 1908, as the band arrived to participate in the festive McClure Bean Soup, the reunion of G.A.R. veterans from Snyder County units.

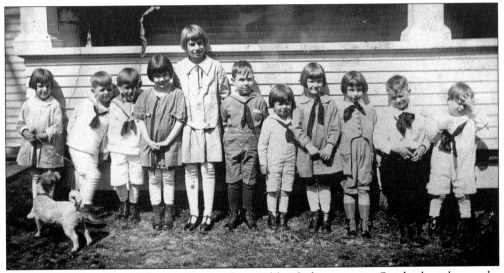

Birthdays are cause for celebration. Invite the neighbor kids, wear your Sunday best, have cake and ice cream, and then line up for a photo opportunity. This Selinsgrove occasion is a celebration of Bob Burns's fourth birthday on April 3, 1925. The lineup includes, from left to right, Midge Steffen, birthday boy Bob, Bob McFall, Elizabeth Moyer, sister Barb Burns, Bill Deibler, brother Jim Burns, Sue Johnston, Eleanor Benfer, Elwood "Bud" Fisher, and Charles Rothfus. The dog "Yucky" (which is probably a corruption of "Lucky") looks on.

Depending on whose propaganda you believe, college homecoming football games began at the University of Missouri in 1911, at Iowa in 1912, or at Minnesota in 1914. Susquehanna University in Selinsgrove was not too far behind the learning curve by staging a homecoming, or alumni day, on Saturday, November 22, 1923. Lytle's Drug Store on Market Street—Howard Lytle bought the store from W. H. Tegler in 1916—provides a fascinating display of team spirit in its window. Cott's and Cole's were other drug stores at the same location. The Bears of Ursinus downed the Crusaders, 17-6, in the big game.

This classic photograph is of an ox roast at the Shamokin Dam Fire Company over the weekend of August 22–23, 1930. It looks as though one man is adding a bucket of basting to the ox. Try as we might, no one could identify any of the men. Perhaps it is a group from out of the county with a mobile roaster.

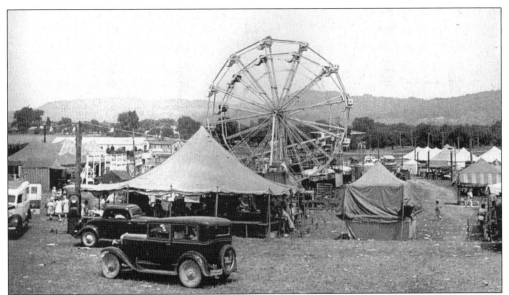

One of the biggest events in a youngster's life is "fair week." In much of Snyder County, that meant the Selinsgrove Night Fair, sponsored by the Dauntless Hook & Ladder Fire Company. The location shown in this July 1942 picture is on the grounds of the Selinsgrove Speedway. The decades of the 1930s to the 1950s were the fair's halcyon days. Stars of stage, screen, and radio—television would come later—appeared nightly. The midway was packed with rides, shows, and "gyp-joints."

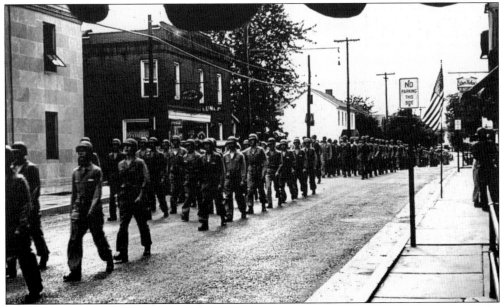

During World War II, the government made use of many colleges as training sites. Snyder County contributed through the use of Susquehanna University. The cadet program—members of the 35th College Training Detachment (Air Crew), Army Air Corps—was vital to the survival of the university. Shown marching down Pine Street toward Market Street in the fall of 1943, the cadets form an impressive group. Locals often turned out as the cadets marched, trained, drilled, and paraded.

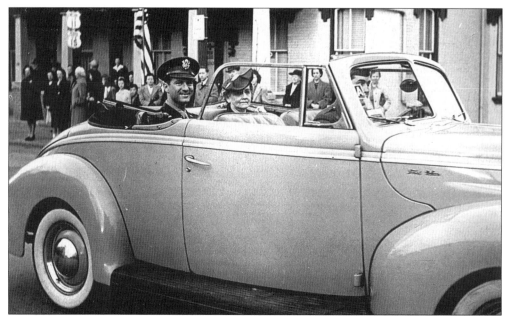

Lt. Col. Johnny Oberdorf of Selinsgrove was feted with a parade down the main street of his hometown on Friday, April 9, 1943, complete with a ride in a yellow Ford convertible. His proud mother, Mrs. Celeste Oberdorf, is seated by his side. While deserving of the honor on the above date, Colonel Oberdorf would gain further accolades and medals as the architect of the entire airborne operation over Normandy on D-Day, Tuesday, June 6, 1944. He was also the first to ever rescue a downed glider.

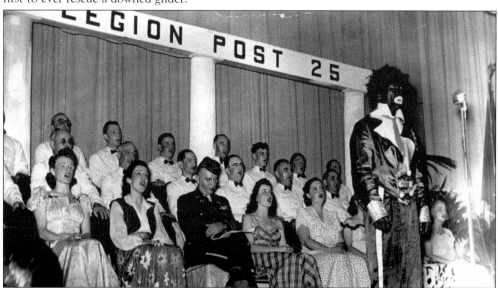

The minstrel show put on by Selinsgrove Victory Post 25 of the American Legion was a true community endeavor. Legionnaires were an integral part of the talent. Bill Hetherington, shown in blackface as an end man, was a key performer. He is probably leading the singing of a patriotic song. Also making the annual show a success were the high school band, singers, dancers, and others. The show peaked in the years right after World War II, the time this photograph was taken.

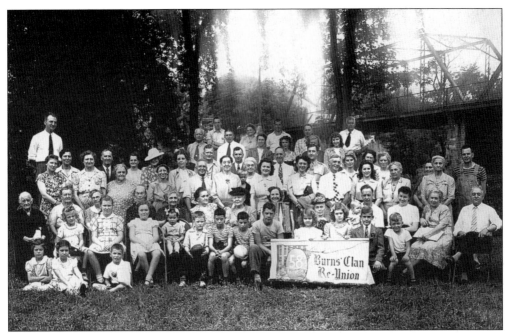

The Burns family of Selinsgrove was one of the community's most prominent families. When the clan gathered for a reunion—as shown for the 58th annual reunion in the summer of 1946—it was such a gala event that neighborhood kids (non-Burnses such as Johnny and Danny Gaglione and Ned Long—all in the first row near the banner) joined in. Note the accordion player in the middle. The gathering took place at Little Norway, which became a winter wonderland in colder weather each year from 1938 to 1968.

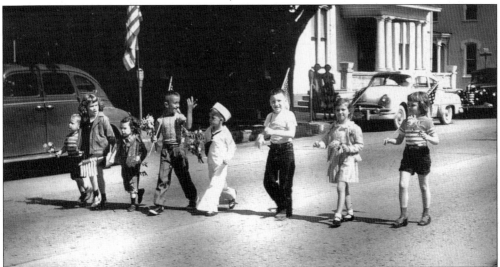

Although vaguely reminiscent of *The Spirit of '76* (1776), this is really The Spirit of '53 (1953). A group of Selinsgrove youngsters forms its own color guard and marches down the first block of North Market Street on Saturday, August 22, 1953, as the borough celebrates its centenary. From left to right are "Bootie" Beck (second from left) escorting two unidentified tots, Charlie Rice waving to the crowd, an unidentified sailor (perhaps Chip Wagner), Donald "Pete" Sears, Dian Smith, and Tanna Burns.

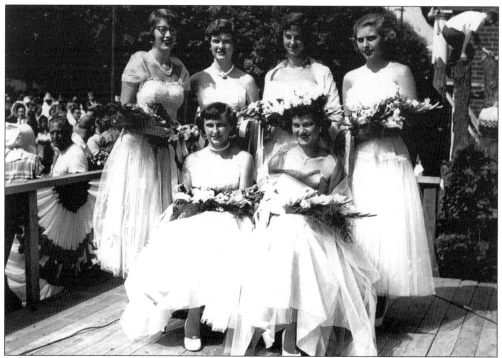

One of the highlights of the 1953 Selinsgrove Centennial celebration held August 21–23 was the naming of the Centennial Queen and her court. These attractive high school–age young ladies are, from left to right, as follows: (seated) Lorene Bailey and queen Margie Lamon; (standing) Carole Hetherington, Pamalee Riegel, Jackie Brungart, and Barbara Laudenslager.

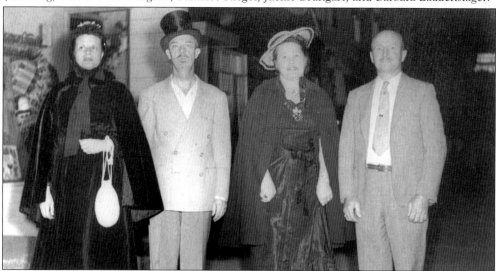

For many, the 1953 Selinsgrove Centennial was an excuse to break away from the ordinary. Clothing that had lain dormant in closets, cedar chests, and attics was given new life. Men who were averse to shaving had a real reason not to—a clean face could land you in front of the Kangaroo Kourt on this occasion. Like many of their fellow citizens, North High Street neighbors, from left to right, Evelyn and Howard Campbell, and Isabelle and Jere Reigle went along with the program.